Madness and Creativity

Number Eighteen

CAROLYN AND ERNEST FAY SERIES
IN ANALYTICAL PSYCHOLOGY

David H. Rosen, General Editor

The Carolyn and Ernest Fay edited book series, based initially on the annual Fay Lecture Series in Analytical Psychology, was established to further the ideas of C. G. Jung among students, faculty, therapists, and other citizens and to enhance scholarly activities related to analytical psychology. The Book Series and Lecture Series address topics of importance to the individual and to society. Both series were generously endowed by Carolyn Grant Fay, the founding president of the C. G. Jung Educational Center in Houston, Texas. The series are in part a memorial to her late husband, Ernest Bel Fay. Carolyn Fay has planted a Jungian tree carrying both her name and that of her late husband, which will bear fruitful ideas and stimulate creative works from this time forward. Texas A&M University and all those who come in contact with the growing Fay Jungian tree are extremely grateful to Carolyn Grant Fay for what she has done. The holder of the McMillan Professorship in Analytical Psychology at Texas A&M functions as the general editor of the Fay Book Series.

A list of titles in this series appears at the end of the book.

Madness and Creativity

ANN BELFORD ULANOV

Foreword by David H. Rosen

Texas A&M University Press • College Station

This paper meets the requirements of ANSI/NISO Z39.48–1992

(Permanence of Paper).

Binding materials have been chosen for durability.

LIBRARY OF CONGRESS CATALOGING-IN-PUBLICATION DATA

Ulanov, Ann Belford.

Madness and creativity : clinical meditations on themes in the Red book of C.G. Jung /
Ann Belford Ulanov ; foreword by David H. Rosen. — 1st ed.

p. cm. — (Carolyn and Ernest Fay Series in Analytical Psychology ; no. 18)

Includes bibliographical references and index.

ISBN-13: 978-1-60344-949-6 (cloth : alk. paper)

ISBN-10: 1-60344-949-3 (cloth : alk. paper)

ISBN-13: 978-1-60344-995-3 (e-book)

ISBN-10: 1-60344-995-7 (e-book)

1. Creative ability. 2. Mental illness. 3. Jungian psychology.

4. Jung, C. G. (Carl Gustav), 1875–1961. Liber novus.

I. Rosen, David H., 1945– II. Title. III. Series: Carolyn and Ernest Fay
series in analytical psychology ; no. 18.

BF408.U436 2013

153.3'5—dc23

2012038475

Cover and frontispiece illustration by Barry Ulanov

In gratitude
to my analysands
and for the work
we do together

Contents

Series Editor's Foreword, David H. Rosen ix

Acknowledgments xi

Introduction 1

PART ONE: Madness 5

 1. Personal Madness 7

 2. Collective Madness 20

PART TWO: Creativity 39

 3. Compelling Complex 41

 4. Creative Return 71

Notes 95

Bibliography 103

Index 113

Series Editor's Foreword

David H. Rosen

Ann Ulanov's meditations in relationship to *The Red Book* resonate with my own. She is correct in that reading that book precipitates a crisis. As the Chinese say, a crisis is both dangerous and an opportunity to grow and develop. Reading *The Red Book* brought back memories of my own brush with suicide. So be prepared for your own egg to crack or shatter. Hence, I recommend that you create or join a group to read and discuss Jung's exciting volume. I also suggest contacting a Jungian society or a Jungian analyst if need be. *The Red Book* is upsetting—even shocking—yet there is quiet after the storm. Finally, digesting Ulanov's fine book will assist anyone attempting to read Jung's great work. *The Red Book* and Ulanov's thoughtful reflections remind me of the accounts of brave individuals who creatively processed their own experiences of madness: William James, Clifford Beers, James Hillman, William Styron, and Kay Redfield Jamison, to name only a few. Jamison, in particular, has written a brilliant text on madness and creativity. All of these souls, including Jung, feel like fellow travelers into a wild, dark, and uncharted land.[1]

Synchronistically, like Ulanov, I have always focused on the light in the darkness and the healing nature of the creative arts. Stanton Marlan, a previous Fay author, also highlights finding light in darkness as a critical healing process. In addition to "letting go and going deeper," I endorse the sacrifice of the ego or "ruling principle" and the rebirth of one's authentic self. The ego is secondary to that which is beyond the ego, which resembles some kind of higher power.[2] Truth be known: this is why I gravitated from Freud to Jung.

The Red Book is about Jung's break from Freud and his journey to psychic Hell and back, that is, the transformation of his madness into creative purpose. Rightfully so, Jung includes evil in this process. For how else can one know the good without knowing the bad?

Jung's *Red Book* and Ulanov's meditations on it are honest and illustrate meaninglessness, murderous rage, darkness, hopelessness, and their enantiodromia to the guiding light of meaning, joy, inspiration, and hope. The last three positive attributes are the title of the first Fay Series book, by Verena Kast.[3]

The key to it all is as Bob Dylan prescribed: "You're gonna have to serve somebody." In other words, we need to serve something beyond ourselves, which draws me near to Emmanuel Levinas and his *Ethics and Infinity*.[4] Levinas maintains that "being," as described by Martin Heidegger, is not sufficient; something beyond being (or ego) is required after one stares into the face of evil and goes through a personal death and rebirth experience. This is the struggle with the God-making capacity that is so essential to each individual and for the survival of planet Earth.

After Ulanov gave her Fay lectures, I felt a kinship with her. Yes, we are both Jungians, but it is more. I feel that she is my soul sister. This is an exceptional book by a wise person.

DHR
College Station, Texas, and Eugene, Oregon

Acknowledgments

My abiding thanks to Carolyn Fay whom I met at her Houston Center many years ago when my late husband, Barry Ulanov, and I lectured there. We were struck by the quality of her creative presence manifested in the art, music, dance, and presentations. Carolyn's gift of Jung through the Fay Lecture Series, with books to follow, continues her gift of Jung's Analytical Psychology to many generations. My warm thanks to David Rosen and his committee for the honor of inviting me to do the Fay Lectures for 2012 and for his presiding over the lectures and their transformation into a book. My warm thanks to Judith Herrick Beard for her unfailing skills and kindness in typing my draft into a manuscript.

Madness and Creativity

Introduction

Madness and creativity share a kinship. These four chapters present two halves of the same whole. The first two meditate on forms of madness. Chapter 1 takes up madness in ourselves, of breakdown, breakup, breakthrough in our personal lives. Madness is real; we all know about it; we can be shattered by rejection, captive to post-traumatic stress disorder after exposure to war or crime. People speak of feeling crazy as what brings them into analysis. A highly functioning woman says she fears she could go insane. An executive partner in her firm comes because life is stalled; she lives suspended. A professor comes because in the midst of her lecture, her mind falls blank and she is mute. A man comes because he needs a place to tell his story, find its thread through three years of being jobless despite a hundred applications and a half-dozen interviews. We all know about madness, our own versions particular to our biography, neighborhood, and country and our time in history. We are located.

Madness dislocates us, out of our bodies, out of our minds. And yet, and yet, in the midst of madness dots of light appear; Jung calls them scintillae. These act as creative points indicating something bright, hopeful.[1] Strung together, the dots construct a path, which can transfigure our madness into our creative contributions.

These meditations on my clinical work relate to what Jung discovers at the height of his having attained riches, fame, and happiness:

an essential something has gone missing—his soul—and he is driven to find it. His path descends into chaos. There he encounters many others, who present otherness itself in multiple forms, points of view that countermand his beliefs and leave him in confusion, wandering, ignorance. Something happens to Jung, and when we read *The Red Book* something happens to us, too. We are addressed, summoned, pushed to find the essential missing thing that enlivens the whole, the multiplicity that makes up the complexity of living. Jung's breakdown of all he relied upon as rational, scientific, good, arrived at through thinking, breaks up his vision of the world and delivers him into meaninglessness as "the other half of life." He loses his vision of the good and faces evil looking at him.[2]

Chapter 2 takes up madness in the world. Personal experience of our madness opens us to collective anxiety about meaninglessness. We fear we have lost sure grip on principles of order and debate in government, trust in social goodwill and fairness, just use but not abuse of collective power. But worse, we fear we lose the means to think about meaning, to imagine recovery of foundational truths. Everywhere the world is erupting into violence and rapacious use of resources of earth, water, animal and plant life, even air. Wars, and their aftermath of rape, genocide, crippling of civilians as well as soldiers, overwhelm and frighten us. Patterns of collective life seem to be breaking up. No containing myth of meaning brings us together with enough room for our differences.

Working on our own madness leads to deep uneasiness; is there any sure meaning to depend upon? The analyst's office is not shut off from the world; the world lives in our clinical sessions. We look for something outside ourselves to depend on when we lose our job, but our joblessness opens onto national economic recession, public demonstrations that question how money is moved around in our society, whether it be Wall Street or French banks. Our search for meaningful employment opens onto our fear of national or even worldwide economic instability. This meditation relates to Jung's discovery that what he was seeing in chaos was not his personal psychosis (the clinical term for madness we all know in one form or another). What he was undergoing belongs to all of us as patterns of human psyche. What we take as social and personal order is right next to chaos.

Jung endlessly urges us, even shouts at us, *This journey I describe is mine; do not imitate my mysteries; you have your mysteries, find and follow them.*[3] He shows tremendous faith in the psyche and in the efforts of each of us to follow its dots of light. Even evil, he discovers, finds its place in being bound into the foundation stone of life. *The Red Book* can be read as a testimony of madness that transfigures into a fountain of creativity.

The second half of the book features creativity. Chapter 3 focuses on the complex that haunts our whole life and usually lies at the basis of smaller issues that we conquer and assimilate into fuller living. Our life-long complex resounds like a musical theme with countless variations, playing itself throughout our life. It is a twenty-first-century version of our ancestor whom we cannot disregard without peril of being held hostage by compulsions that repeat over decades. We know this humiliation of being caught, forced to repeat a prescribed work schedule, sexual routine, evening drink, special rewarding food, reassuring pills, shopping excitement, fixed prayer forms, strict allegiance to political party, an unquestioned God-image. Trauma enforces such captivity. Like a child's superstition not to step on cracks in the sidewalk, we adhere to our defenses lest we fall to pieces. Here I dare two convictions my clinical work has created: our problem turns up in our solution to it, and more, our problem itself shows the path we are to follow to creative living. Creativity relies on a new kind of meaning that includes meaninglessness. Our dogged complex bestows precious legacies on us.

This meditation relates to Jung's insistence that we live our very own life—not his, not our hero's, not our mother's, not our analyst's, but our own which finds meaning that includes meaninglessness. Jung's devotion to this task sums up the creative path he discovers in *The Red Book*. He says of the visions, texts, and paintings in that volume that they were the decisive experiences of his entire life and he spent all his remaining years putting them forth into the world.[4] His path unfolds in service to something beyond himself. Finding himself relates to finding his image of God. In his 1912 lecture in America at Fordham University, he says: "My personal view . . . is that man's vital energy or libido is the divine pneuma all right and it was this conviction which it was my secret purpose to bring into the vicinity of my colleagues' understanding."[5]

Chapter 4 focuses on the transformation of our compelling complex (the subject of chapter 3) into creative return, that is, a circling around at different altitudes that which comes into being in our human psyche. We create and find something that arrives that we do not invent. We develop a ritual through which we return to different levels in our complex to transform our path toward what we come to recognize we serve.

Jung discovers in *The Red Book* another center to the psyche and traverses back and forth between its multiple points of view within him and in the world, represented in encounters with different figures to whom Jung pays close attention, never trying to reduce them to one. Multiplicity, decentering, disrupting human forms of order that we identify with and then prescribe to others, come together in what Jung later calls the *complexio oppositorum* that makes up a wholeness that allows for our differences, too. There is no one final unity that moves like a big ship into view to dominate the ego. And yet, and yet, this multiplicity Jung also describes as making a unity, a wholeness where every part of us and of our world gets a seat at the table, engendering compassion for marginal and rejected aspects of ourselves and our communities. This attentive compassion to all of our soul life begets respect and justice toward our neighbor. Without this we unconsciously force our neighbor into adopting what we revolve around as a god.

The questions emerge: Around what do we revolve? And what place does it give for evil in life? How does our ritual show our central devotion? What is our God, or, as Jung says, our God-image? He makes a distinction: it is not God who comes but God's image, "*The supreme meaning is the path . . . the bridge to what is to come. . . . It is not the coming God himself, but his image which appears in the supreme meaning.*"[6] We, too, must account to our own god-making capacity, what we find and create at the center that we serve, even if we say it is not a god but something else.

This fourth chapter relates to Jung's discovery of our god-making capacity. He opens *The Red Book* with quotations from Isaiah and from John's Gospel announcing the new god who emerges in the gap of our parched, barren state. From that very place, filled with grief and fear, anger and despair, the desert will blossom as the rose, streams of water will flow, the enlivening word steps into embodied life.[7]

PART ONE

Madness

Personal Madness

Madness belongs to all of us. It comes in many forms and many degrees, from the craziness at the bottom of our neurotic symptom to a derangement that engulfs our whole life. Madness is simpler than it looks: it is our effort to express unbearable pain. Pain of shame, of humiliation for "not having the goods"; pain at being annihilated as a person with agency over her own life, treated as of "no account, so no accounting is necessary"; pain of catastrophic anxiety, so one goes dead to communicate being made dead; pain of being treated as another's object, at their disposal, like a prop for sexual release or burst of violence, filling their need to get ahead, steal one's land, annex one's country.[1]

Breakdown

Madness springs from the shattering of our self. We communicate this loss by living in a void, a no-man's land. We use supervigilant control to prevent our flying into myriad fragments. But that control stretches to a vibrating extreme and then snaps. We become confetti. Or madness shows in an engulfing fog of abysmal confusion, obscuring any orienting direction of north and south or time sense of then and now.

We cannot represent in word or image what is happening to us. We spin into outer space, out of body, out of mind. In dread of disintegrating panic, we do not go outside, lest its terrific force fell us in the supermarket, as one man said, leaving him lying in the aisle as women push their grocery carts over him. Madness on the way to recovery digs up parts of us left in shadow that are unadapted, still archaic, so that we feel as bizarre to ourselves as we appear to others. Yet we need just this primitive energy to find our way through madness.

I am aware that this subject introduces strain. Speaking of madness brings it near, felt, breathed in again, with all the dissolving of meaning that madness inflicts. Through the generosity of my analysands, who give permission to cite some of their words, we can feel the theme of madness and associate our own specific variations. To bring in as well Jung's experience described in *The Red Book* bolsters our courage to look into our madness, to see what is there and not there for us. Something happened to Jung that took him down, gripped by necessity to find what he missed. For us to read this volume is to fall into a world that astonishes, for we are gripped as well. We can take courage from Jung's saying he also felt "violent resistance . . . and distinct fear" to engage these erupting fantasies.[2]

To approach madness in the more customary way, through clinical terms for disorders of mental distress, puts it at a distance and removes us from the scene, as if madness happens only to the other guy. I do not want to do that for two reasons. Labels such as borderline, narcissistic, and the like make us feel judged; we recognize bits of ourselves in these disorders and feel fear when put into categories of craziness. Also, madness is not ours alone, but part of the human condition; we cannot segregate it over there apart from our own lives. Jung asks, "What is there, when there is no meaning? Only nonsense, or madness." But, his soul declares, "*Nothing will deliver you from disorder and meaninglessness, since this is the other half of the world.*"[3] Any meaning we find or construct must, then, include this other half, too. Recognizing that bears huge implications for our shared existence in society and for our religious attitude, whatever that is, including our rejection of religion and things spiritual.

Trying to speak and write about madness induces its felt impact:

words slip, slide, and break, fall into nowhere. Disorder defeats any clear line of exposition. Like a spell or a fog or pollen in the air, to speak of madness is to be infiltrated by experiences of its derangement that we both know and deny. I do speak and write about madness precisely because it is a country we share.

A specific Jungian view of what promotes healing includes knowing that our particular suffering partakes of human suffering. The personal and impersonal meet, and that nexus counteracts the horrible isolation madness imposes on us. We feel crazy, and no one can understand and we cannot explain; that conviction is itself a symptom of the madness that afflicts us. To know in fact that we share in a larger human problem relieves our humiliation of being caught like a rabbit in a trap and softens the isolation we feel from being subjugated to a force outside our agency, tempering our judgment that we are insane. Seeing our madness as part of the human condition restores dignity of meaning to our suffering. We are working on a human problem, in our own small version of it. Insofar as we find solutions and release, we contribute this healing to others; we do our small part to contribute to the healing of suffering in the human family.[4]

To know and accept our role in the community quiets our strain and may even replace it with curiosity about this state of being, a being-state that feels like nonbeing, a nothing state. One analysand describes it as a life lived in an airport, arriving from nowhere and departing to nowhere, just wandering to and fro in nonexistence, triviality, emptiness. This description echoes Jung's in *The Red Book* of Hell: "There is nothing but motion. . . . Everything merely surges back and forth in a shadowy way. There is nothing personal whatsoever."[5]

Madness is traumatic; it tears us from our familiar self, leaving a gap so big that it threatens us with no return once we fall into it. Trauma brings its own vocabulary, which we learn bit by bit in the aftermath of the shocking event that instigates it, such as a murder or suicide, a mugging, a rape, a terrorist attack, or that cumulatively doses us over years with dread of its recurrence, such as incest. Or trauma can result from lack, what is not there, what was not done and should have been given, such as being welcomed, noticed, picked up and loved, not blocked out by another's depression or tragedy. Our defenses of our

fragile selves can hurt others; our failures to thrive can eclipse the life-giving warmth of emotion to our children; our fearful withholding can blight the growth of affectionate living with our partners.

Madness springs from hurt that goes deep, that ruptures our sense of self, leaving us helpless to shelter the person we are becoming. We lose a sense of agency over our own life and fall victim to how another defines us. Our thread of going on being is broken, and we live with this gap in our identity.[6] Our sense of being alive feels intruded upon and disturbed; there is no rest for us anywhere.

The specific vocabulary such traumatic experience leaves in its wake is a complex of images, emotions, and behaviors that differ among us but hold in common a sense of being in the grip of a force that compels us to go round and round with obsessive thoughts about what happened or should have happened, what we failed to say or do in response. We feel utterly defeated, unable to verbalize or find an image for what has happened to us; instead, we walk around dazed, mute, caught in an abyss of confusion. We feel obliterated, cast aside, discarded like so much trash, not merely rejected, but annihilated. We feel blanked; no meaning is graspable, no value in our self, but vacated, a no-thing.

The lost good object is our self.[7] We can make nothing of what has happened to us. We lose the world, too, the connection to others, to any sense of space between us, to meanings we inhabit together. In analysis, this mad state may express itself in staring blankly, or weeping uncontrollably, or falling into futile silence. What Jung calls a complex is what we inhabit now, but a complex of imagery, emotion, behavior that is no longer a normal part of our psyche, but abnormal in that it overtakes our ego functioning.[8] We are in it, pushed round and round in a washing machine without end, with no release into fresh perceptions laundered of madness, but only the lunacy of retelling the hurt, the insult, the injury, the being treated as a worthless object in another's sight or in society's disposal of us into unemployment, a psych ward, an item in a psychoanalytic theory. An analysand who became a scientist grew up in a ghetto where he heard from the cops, schoolteachers, adults on the street that he was nothing and would always be nothing.

Psychosis is a modern word for such affliction of nonbeing, such loss of heart, such loss of soul, so urgent that Jung found he had to go looking for it and, indeed, came to see this was the search for all of us, the plight of "modern man." Analysts with different theories know about this gap and write about it as basic fault, deadness, false self, fusion complex, or centers within us of not-I-ness.[9]

Knowing and Not Knowing: A Complex

Madness yields a strange knowing and not knowing, inducing in us separation from whole areas of experience that something in us knows but that we do not consciously register. We do not represent this experience of disorder to ourselves in word or image. It is dissociated, not repressed, because it never was conscious.[10] The meaning exists in us in our body and shows in our behavior, so we repeat destructive actions, knowing and not knowing we are doing this.

For example, a woman continues to see a man who, while with her in a restaurant, is asking the waitress's phone number. His disregard for my analysand made her feel suicidal. Her continuing to see him made her feel caught in lunacy. Only in willingness to take on the pain of painstaking work to look into this mad repeated behavior did she become conscious that the emotional abandonment he inflicted dragged into light her earliest abandonment. She knew about that loss as abstract information but never registered its deep suffering. At birth her mother left her with her grandmother for three years. When the grandmother died, without explanation to her three-year-old self, she was whisked back to her mother. Her current reenactment that made her feel mad, exposing herself to this man's destructive behavior, she came to see was her effort to feel the connection between what was happening in the present and what had happened in the past. Unconsciously her compelling behavior pushed into consciousness a coherent complex that in effect stated, I feel emotionally abandoned and want to kill myself. Achieving such clarity of image, affect, behavior allows a complex to cross over into consciousness, where we can relate to its symbolic meaning.[11] We can find words to talk with ourself and communicate with another what we suffer, find images

of distress, recognize impulses that we can behold and study. Space emerges between us and our former compulsive behavior. We find its meaning.

Or, after many years a man divorces his wife to whom he had to devote time and energy to take care of her because of her mental distress. He marries another who needs his constant care for her physical distress. The known-unknown thing he attends to in his partners moves around to different locations, first the mind, then the body, but his repetition of choice in a partner bypasses consciousness because the trouble still locates in the other, not himself. Our somatic problems can carry unlived psychic afflictions trying to get into consciousness. Legitimate physical maladies, often chronic and grave and arising from physical origins, get made use of to signal unfelt psychic contents or actions—for example, sorrow that needs to be lamented consciously, not wept out through blistering, weeping sores of the body.[12]

The complex rules us and traps us in its repetitions; yet the complex tries to communicate something we know and do not know, need to know, to unravel and find symbolic representation for, so we can be freed from acting it out and discover what precious part of ourself has been sheltered there. These dissociated behaviors are painful to endure—symptoms of losing things, of getting sick before social engagements or professional presentations, of leaving preparations to the very last minute or even losing opportunities because of procrastination. We feel trapped in their iterations and defeated again and again. Yet the complex, like a good dog, keeps at us, herding us toward the opening into consciousness to receive its communication. Hiding there are dots of light. Madness and creativity coexist.

Social Effects

Our madness is not ours alone but infects others, often gravely. We drive each other crazy. Clinicians know this and have long training to recognize their countertransference in order to have in mind their own potholes where sanity gives way to insanity. Yet clinical work in depth requires the analyst really to experience where the analysand is

caught in knowing-unknowing, like the woman who knew perfectly well not to continue seeing the man who flirted with other women under her nose, but she did it anyway.

In another example, a man whose multiple wives and lovers all end up refusing to talk to him goes on presenting himself to himself and others as reasonable and commendable, dismissing his partners as "these difficult women." He remains unknowing of the poison he inserts into them. He sounds rational, friendly, innocent, all the while emotionally abandoning the woman, removing himself from her, thus making her feel crazy, destroying her grasp of the situation. The clinician has to go into the analysand's mad state to look around, feel its power, to see that things are not what they seem and locate with him the path to consciousness, which is a dangerous role to be in. Sue Grand describes what every clinician feels when we cannot do this: "I could not fall through the holes in my known world," that is, into the mad world of the analysand. When, together with the analysand, we connect with the area of madness, "new forms of subjectivity make their appearance." Schwartz-Salant sees madness as an overwhelming, disordering inner state that occurs when we seek new forms of order. How does one suffer chaos without losing one's mind? How does one find that imaginal space to make hidden meaning visible? That is the work of therapy; that is the message the repeating complex is trying to deliver.[13]

Not only do we contaminate each other with what makes us feel demented, uncentered, inferior, that is ours to look into; we also instead locate it in the other. You are the problem, even you whom I love, not just you who are my enemy; the other group is deranged.

The effect of our madness in the larger society stems from its being contagious. We can derail those who love us from plain speaking. They become wary strategists to get around the elephant pit of our complex. If they are the mad ones, we defend against their madness, urge them to "move on," "get over" the hurt and anger instead of trust truth between us to win through. Without a shared container of meaning, those with larger rations of psychotic elements in themselves act out publicly the mental illness. They strap on bombs to get rid of evil we all fear, that they have translated into the narrative of

their own madness. They transmogrify their own life into a weapon to kill others, to make deadness in the name of serving a living God, a cause, or a collective vengeance. The madness is not just personal but extends to whatever we believe is our guiding meaning, to hold it now as a religious duty to enforce. Our madness connects with our religious attitude, what we say is the good, the true, the worth dying for. Even if our cause is to wipe out religion, the passion of devotion is as if to a god.[14]

The Ruling Principle

Jung calls this guiding meaning our "ruling principle," our version of the good we heroically seek to embody and enforce. This does not work because we want to ascend "to become part of its magnificence" and leave out the bad, because the "good and the beautiful freeze to the ice of the absolute idea, and the bad and the hateful become puddles of crazy life." In making our version of the good, the principle that should rule, we make a god and try, with "unconscious cunning and power," to coerce our neighbor to serve it: "Enamoured of our own design . . . we . . . demandingly . . . force others into following the God." We fail to see its one-sidedness, its implicit exclusion of others who have different guiding principles. Others must believe in our good, our cause, or they are the violent ones; we are serving truth. Jung says we must accept the violence as part of ourselves lest we kill in our neighbor, literally or through discrimination and prejudicial laws, what we cannot accept in ourselves.[15]

All this must be sacrificed, Jung learns. Against his repugnance, he submits. The sacrifice is to sever our identification with our "formations," what we hold supreme as the ruling principle—for Jung, his thinking, his science. The ruling principle for each of us is the hero in us who must be slain: "The heroic in you is the fact that you are ruled by the thought this or that is good . . . the goal. . . . Consequently you sin against incapacity. But incapacity exists. No one should deny it, find fault with it, shout it down."[16] To lose our guiding meaning, our ruling principle, can make us feel mad. What we relied on before, that gave us energy to pursue our goals and reference points through

storms of conflict or self-doubt, now proves irrelevant, useless, or defeated by its opposite looming up.

Here are examples. The executive who seeks analysis because her life feels "suspended," took meaning from the principle of "work harder," "be responsible," "you should know." But working harder closed a trap around her; being more responsible increased her estranged distance from the flavor of life. What had helped her succeed in the past now left her suspended, watching television, sitting on the couch blanking out, in resistance against more and more work and responsibility.

A young man devoted to being heroic, by which he means fight, win, be strong, find power and exert it, grew more and more exhausted and finds he cannot ignite meaning and passion this way anymore. But what makes me cling to it? he asks. He discovers great fear of its opposite, what Jung calls "incapacity," and he calls the "Void"—going into a nothing place where he is swallowed in sloth, not finding and creating his self as before but feeling futile, vacant, unused, unable. The loss of heroic verve deeply frightens him.

A woman whose life principle is to do simple acts of kindness, because she believes in this good and because she feels inferior intellectually, that she has nothing to offer, loses the sustaining support of this belief when insistent needs to find and claim her mind, to speak as an authority to her children, to present a public piece of work to her colleagues all rise up within her. She must do this and do it her way, defying implicit rules of her organization. To remain in the background is no longer possible.

Relation to Red Book Themes

For all these people, loss of their guiding meaning that makes sense of life, gives them purpose, is like Jung's experience that order includes disorder and meaning, meaninglessness. Does this bigger picture invalidate these images of the good that guide our lives with meaning? No. It relativizes them. We see that our constructions of meaning are not ultimate; they improvise and orient; we need them. They are precious values we arrive at. But they are finite.

In *The Red Book*, Jung wrestles with what acts as if a god at the center of our lives and around which we circle. He says, "You cry out for the word which has one meaning, so that you escape . . . from countless possibilities of interpretation," but, "You should be a vessel of life, so kill your idols." Jung sees he has privileged as his ruling principle thinking over feeling, Logos over Eros, the masculine as connected to Logos over the feminine as connected to Eros, the science of the day over another way of grasping reality that he calls magic, intellectual intelligence over paradoxical understanding. The issue is not to get rid of what he finds superior, but to include the neglected opposites along with it, to dethrone it from its superior perch. To renounce the ruling principle as the only truth means seeing he has excluded a whole other half of life that must be embraced. Otherwise, even the superior parts of us become distorted, "an ugly dwarf who lives in his dark cave . . . false and of the night."[17]

Jung's soul confronts him: "Be quiet and listen . . . recognize your madness" (in taking one's own ruling principles for the truth). "Life has no rules. That is its mystery and its unknown law." And further, "Nothing protects you against the chaos other than acceptance."[18] Hence this is not a problem to get over but a reality to accept. It demands further grave steps.

Through encounters with multiple figures, each with its own point of view, any notion of having a united self is disrupted. Instead, Jung is shown a multiplicity within his self. He discovers that a host of different perspectives inhabit him. He feels "the boundless, the abyss, the inanity of eternal chaos . . . rushes toward you . . . , an unending multiplicity . . . filled with figures that have a confusing and overwhelming effect." There is another way of reasoning that goes with unreason, nonsense with sense, the laughable with the brutal, the high with the low, the shameful with the pleasant, even the bad with the good.[19]

Jung feels the threat of madness and fears he is breaking down into psychosis, so strong is his disorientation. And it is matched outwardly by his severance of friendship and colleagueship with Freud, his repudiation by the psychoanalytic community, and his resignation of his university position. He sustains this rupture by his conviction that he cannot unequivocally agree with Freud's theories nor teach psychol-

ogy as it is then conceived when his own work gives evidence of a very different understanding of psychic reality. Inner rupture and outer loss are matched by the horror of Europe's plunge into World War I. Collective belief in inevitable human progress and the supremacy of reason is demolished in the bloodbath of trench warfare.[20]

Jung is confronted with even more encompassing madness that sees that the Divine is different from the conventional view of the "spirit of the times" and that sees "the problem of madness is profound. Divine madness—a higher form of the irrationality of the life streaming through us—at any rate a madness that cannot be integrated into the present-day society."[21] This streaming life, which he later calls the god Abraxas, is shown him by the spirit of the depths as the living current of life, not to be explained away by our efforts to make order, to craft principles of meaning that rule us, to devise our versions of the good.

Reading this, we can feel the threat of losing our axioms of ordering knowledge and ethics just as the analysands I quote feel in losing their ruling principles. Does it mean the ethics are bad or wrong? No. They are good, our versions of the good, our "heroic" constructions that confer meaning on us. But they are not conclusive. When we lose them, when they prove ineffective, we lose our sense of meaning we have relied upon.

But Jung reaches a kind of peace; he says, "I accepted the chaos." Then his soul tells him "madness is a special form of the spirit and clings to all teachings and philosophies . . . and daily life." A larger view moves onto the scene in which what we lose as definitive emerges as part of the whole, just not the whole in itself. This changes our sense of self. We must now develop what we rejected along with what we developed. This makes a bigger whole and changes our images of God. Jung sees that "madness is divine . . . which is nothing other than the overpowering of the spirit of this time through the spirit of the depths." Accepting what his soul shows him as a larger reality than he had thought depends on a religious reality that includes the irrational, streaming livingness.[22]

This sets us a new task, all of us. In terms of the searches of my analysands, How does one unite flavor of living with an ethic of "work

harder"? How does one bring together the fearsome void of vacancy with heroic ambition to make a difference? How does one put oneself forward as an authority expressing an abstract principle to be heard alongside simple acts of kindness?

Incapacity

In *The Red Book* Jung finds his way to this task and sees it belongs to each of us: we must face the lowest in us, our "incapacity," which is all we exclude when we identify with our ruling principle. When we give up such identification, "our urge to live . . . went into the depths and excited terrible conflict between the powers of the depths." These powers are "forethinking," which is "singleness," and love, which is "togetherness." Jung says, "Both need one another, and yet they kill one another. Since men do not know that the conflict occurs inside themselves, they go mad."[23] But our incapacity and conflict exist, and we must go looking for them in the lowest of our selves.

To get to what he calls "your beyond," we must experience Hell "in fact through your own wholly particular Hell, whose bottom consists of knee-deep rubble. . . . Every other Hell was at least worth seeing or full of fun. . . . Your own Hell is made up of all things that you always ejected . . . with a curse or a kick of the foot. . . . You come like a stupid and curious fool and gaze in wonder at the scraps that have fallen from your table." Our own Hell is everything we would cast off, reject. If we do not face our Hell, we continue to deposit the unwanted, the loathsome, the horrific in our neighbor and try to kill it there.[24]

Let us make no mistake how fearful is this undertaking to include incapacity, to go to the lowest in oneself and embrace all that is inferior in oneself. It really is inferior, other, at far reach from what we know and value. We are faced with something threatening: a rhino staring at us, a mathematician living in our basement. For Jung it was his feeling, left to moral decay, personified as Salome, appearing at first as a bloodthirsty horror, murderer of the Holy One, insane. Even when Salome is redeemed and appears as a loving woman, Jung rejects her love, saying, "I dread it."[25]

Think of everything you hate about yourself, shun, do not want to

touch. That is what you must face. Jung sees he must accept "the repressed part of the soul, he must love his inferiority, even his vices, so that what is degenerate can resume development." This goes against the grain, for what we have developed "represents our best and highest achievement. The acceptance of the undeveloped is therefore like a sin, like a false step, a degeneration, a descent to a deeper level; in actual fact, however, it is a greater deed than remaining in an ordered condition at the expense of the other side of our being, which is thus at the mercy of decay."[26]

This hell, this space of incapacity, of accepting the devil of "your own other standpoint," requires even more, Jung discovered: "You must free yourself from all distinctions," from the "curse of the knowledge of good and evil," because "the lowest in you is also the eye of the evil that stares at you and looks at you coldly and sucks your light down into the dark abyss." At bottom, our madness faces us with evil.[27]

Yet lurking there in that basest space is also a dot of the creative: "The lowest in you is . . . the cornerstone." Accepting that "evil must have its share in life . . . we can deprive it of the power it has to overwhelm us." For "salvation comes to you from the discarded." "If I accept the lowest in me, I lower a seed into the ground of Hell. The seed is invisibly small, but the tree of my life grows from it and conjoins the Below with the Above. The Above is fiery and the Below is fiery. Between the unbearable fires, grows your life."[28]

Hence our personal problem shows each of us that we must deal with the whole notion, whether religious or not, personal and social, of evil. We take up evil and the place of destructiveness in life in chapter 2.

Collective Madness

When our ruling principle and formations of the good, of God, of reality break down, and when we find we must develop the least developed part of us, we find at the bottom of that lowest point evil looking at us coldly, dragging our light into the abyss. Clinical experience bears this out. When we break down personally, we fall into a space beneath the principles and images on which we have relied, away from what used to work in us, what functioned in us in a developed, superior way. All that proves of no use anymore. It no longer works. That leaves us disoriented and frightened. What can I rely on to see me through life? The personal opens to the collective threat of nothing there.

Disorientation

Seeing that our ruling principles are not ultimate truth but at best our constructions of truth, not to be equated with truth, that our images of God are images, not God, throws us into a gap that opens between order and what is beyond order. We do not feel this as an opportunity to explore the ultimate beyond our designs for it, but instead look into an abyss into which fall all our axioms and belief systems.

In personal terms we feel madness because we lose our container of meaning, what guides us as reference point. We feel madness because we have lost our sense of meaning—that we have meaning, that we can make meaning out of what happens to us, that we share containers of meaning with others in our culture. We feel we alone live outside systems of meaning others share; worse, we question whether meaning exists at all.

In collective terms we feel disoriented that whole patterns of meaning have broken up, proved fallible, not firm. No shared container of meaning holds us as a culture, a nation, a world. This feels mad. As Jung says, we feel that "the spirit of the times"—what we know, are accustomed to, take as moral compass—is overcome by the "spirit of the depths," and "if you enter the world of the soul, you are like a madman."[1]

To perceive this makes us dizzy. Are we right in thinking this way? Or have we just missed some basic point that will explain what is happening? Are we just projecting our dis-ease of craziness out onto the culture, the world? Or have we gained an access point to the stress in our culture through its small version in ourselves? Culture does not exist outside us. We live in it as a fish in water, and it flows through us offering us images, laws, customs, personages in comic books, songs, novels, paintings to enhance and explore our identities as well as ways even to think and guide such reflections on self and world. When these guidelines disband into a jumble without a unitary interpretation, or even words to explain what is happening, we feel lost, without foundation. Jung writes in *The Red Book*, "The word is protective magic against the daimons of the unending."[2]

We live in a time when invisible, basic patterns of orientation that sketch a map, a locale, a surround we hardly named or knew existed now rise into mind because they break up. We grab this shard, that pith of content and try to re-form, reinstitute what was. But we are not able to restore this persona of order and meaning. At best it is like a placard, a bunch of platitudes, an enforced way of thinking to revivify worn-out interpretations. It does not feed the soul.

This collective disorientation goes deeper: we lose not just the container of meaning but also our accustomed ways of thinking and feel-

ing about meaning. Myths of meaning that have sustained us dissolve. We try to reduce the chaos to a sure linear explanation. We look for a neat causality to explain what feels like cultural madness. We spy a source of this breakup, fasten on it to blame the other group. Such blaming reassures us there is logic to this disorientation; it is not destruction of meaning but the others' fault, and it can be corrected and we can get back on course.

But examples of disorientation and our conflicting experiences of them leave us in confusion about what has happened and what to do. For some it feels like liberation from old restrictive, coercive patterns; for others it feels like ruinous loss of dearest ideals, undoing of dependable foundations. Together we suffer cultural collapse. The symbols that bound us in shared existence pale, grow weak, do not maintain space for commerce between self and others, between here and now and what transcends it and lasts, between individual invention and enduring truth.

Just as in personal madness when we veer toward rigid holding on to what we knew, no matter what, or when we feel scattered to the winds, so in cultural collapse we split between entrenchment in fundamentals and prescribed ways of thinking about them, with banishment from the group if one disagrees and acceptance of a randomness of standards, as if letting go to the winds of change where nothing abides. Each group blames the other for the cultural crisis.

Examples themselves are problematic, seemingly more anecdotal than legitimate data, because all we have are experiences of breakup, breakdown. There is a generalized suffering in the absence of a shared moral compass to hold us all in freedom and unity, with room to differ without repudiating, to differentiate new views without exiling, to craft identities without legislating them.

Examples

Examples abound of losing the meaning we live in. As I am writing this, a bombing occurs in Oslo, Norway, and a massacre on one of its islands hosting a youth camp. Many have been shot dead—young people. In Norway of the Nobel Peace Prize! How to grasp this madness? How to

understand its happening? What could cause it? An arrest is made, and the perpetrator is described as a right-wing religious extremist, an example of identifying one's viewpoint with the truth, hence, in madness, justifying killing as imperative to make that truth known.

The United States Gulf oil spill not only brought disaster to sea and land creatures, including humans who lost their homes and jobs, but also despoiled faith in a sustaining structure of industry and government to do right by the victims. Like personal trauma that not just eclipses but outright obliterates the existence of the person, the right to be a subject with rights, in national collective tragedy fueled by human mistakes that are denied and passed around as blame to others, the move on the checkerboard is the same. Individual and community safety is eclipsed by profit margins, liability and blame assignment. Particular individuals and neighborhoods, small societies within society, go unrecognized, nor do they receive adequate retributive justice for their suffering of being all but annihilated by poisoning of habitat and erasing of livelihood. No collective mourning happens for loss of beauty of land and sea, no shared remorse for harming earthly resources given so abundantly and now in grave question of continuing. Will there be oil for our way of life? Should there be oil? There is no mourning together for neglect of priceless human caution and for lack of enforcing safety measures out of respect for the sheer force of potential disastrous explosion. No shared mourning recognizes these losses.

In Japan with the earthquake and then the tsunami roiling into nuclear power plants built near an earth fault, the physical upheaval of earth and sea, of towns, homes, highways, pets, and people, a catastrophe fueled in part by ignorance and overreliance on inadequate safety measures not pressed to the limit by imagination of what could happen, for many bankrupts faith in nuclear energy throughout the world. Should all nuclear plants be closed? In New Mexico when wildfires threaten to come near nuclear facilities, the possibility of such a collision is now imagined, safety rules notwithstanding, spreading fear like an emotional pollution. Our faith in our precautions shows fissures. Anxiety seeps from those cracks: What if this or that happens? Danger of the unexpected, the unplanned, now haunts our collective consciousness.

On a symbolic level we worry about energy from the depths of nature erupting, spewing poison into air, water, and soil. Is it retaliation for our exploiting the earth—for ignoring its realities and the creaturely life it supports because of our greed for more and more power, for convenience, for ease of us humans alone? Now we know it can happen. How do we respond? Philemon, Jung's guide in *The Red Book*, accuses the dead who come back because they failed to live their own animal part of never doing penance for "the velvet eyes of the ox" and "for the shiney ore."[3] How prescient!

I think of a personal tragedy also based on collective ignorance. A mother is haunted for decades by guilt for the effects of her postpartum depression on her child. She feels she failed her infant then by falling into an inability to trust the care she was giving her daughter. But she learns years later that her depression was chemically driven by total loss of estrogen before and during birth. No one tested for estrogen depletion then, even though she had a most difficult pregnancy. It was not in the collective medical consciousness to monitor estrogen levels as a crucial factor. Differentiating personal and cultural factors now makes precious space between her and her guilt, to see this impersonal effect that fell upon her body and psyche and then fell upon her infant. This perception, even years later, restores the cultural space where we can inquire into the weight of culture pressing down on an individual.

Jung in *The Red Book* says that we must make such an impersonal event that assaults us personal, to find our way to its meaning even though we did not cause its happening.[4] We thus accept the blow of impersonal events that happen to us and in that acceptance work an alchemy that transforms the outer into an inner event that caught us up, wounded us. By restoring our personal life in that space, space is made in the culture itself for self and symbol to be refound or found for the first time. The mother and her infant suffered this rupture in their beginning. What is the meaning for each of them and for them together? How might she, and later her child, respond and make deep sense out of what happened to them?

Breakup of reliable patterns orienting economic life is happening across the globe. Economic recession, threat of default on loans,

rise of interest rates, refusal of loans by banks across nations, decline of the housing market, joblessness, all like a row of dominos tumble one after the other. This toppling feels like an impersonal happening directly affecting the economic stability of individual citizens across many countries and the countries themselves as collective entities. Does the international financial market grow so nervous that investing shrinks, risk-taking stalls, and the circulation of money, like oxygen for nations' monetary health, begins to fail? Or does the market fluctuate so wildly between highs and lows that individuals cannot devise sensible patterns of investment? Who is to blame? How did this happen? Will the European Union break apart? How can an international union thrive if we feel robbed by other members? And what will happen if everyone refuses to pay more? Where is a just, flexible, durable financial pattern of orienting meaning that contains all of us?

In America, our government cannot come together to reach shared decisions about what threatens our country's health: our debt, joblessness, health care and social security costs. Instead of working together for the good of the American people, we hear daily on the news how each political side digs in its heels, does not yield, insists that the other side move off their position toward what our side says must be. The accusatory rancor displays the bankruptcy of our tradition of congressional debate and compromise. We lose sure grip on principles of order and debate in government, of trust in social goodwill and fairness, of just use but not abuse of collective power. How do we reach an encompassing pattern of meaning to hold us all in a livable rhythm of earning and spending, investing and economizing? No collective myth of meaning unites us, out of which specific effective policies can be generated.

Even countries that boast an expanding economy, such as China, make us ask, yes, but at what cost? Shanghai's transformation into a modern city also leaves many citizens homeless. Their homes and stores are razed to make room for skyscrapers. Evicted citizens bitterly complain of little compensation.

The Hartford, Connecticut, chief of police in a radio interview tries to explain the doubling of murders in his city from the same date the previous year. We need a holistic response, he says, not only

from police, but also from families, religions, economic opportunities. We need for these men something bigger to which they feel they belong. These men are in their twenties, not teenagers in gangs, and the murders happen between persons who know each other. They are not random nor results of robbery. They are intensely personal: you disrespect me, I shoot you. The core issue, I suggest, is feeling annihilated. The police chief recognizes the tremendous boon of technology, but says, nonetheless, these men are living in their daily lives the same way they use the Internet. On the Internet they can act without rules, saying whatever they please anonymously and in any language, living for the moment, with no sense of consequences or of a bigger community to which they owe something. They live for the moment with the click of a button. They are victims of a lifestyle. They shoot without thinking about it. The chief says they need opportunities to get involved, to belong to something bigger than themselves. Nothing intervenes to make a space between feeling disrespected, made to feel they are nothing, and retaliating to annihilate the other. In that gap of pain, no space exists between what is fantasized and acting on it.[5]

A Chicago group in a documentary film called *The Interrupters of Violence* shows how space can be made. One woman, Amina Matthews, herself with authority on the streets from having surmounted her own criminal background, quickly pulls a man away from the group when he is hit by a thrown brick and says to him, I know you do not want to strike back; you want to take care of your family, not return to prison. That is the gangster in you—a major sign of respect but turned inside out to communicate the strength to rule what one feels instead of be ruled by it.[6]

Breakup of a meaningful moral compass shows even in technological advances that are wondrous in what they also achieve. Facebook potentially connects every person with every other person in a vast, sprawling community throughout cultures and the globe. The facility of communication thus provided plays an essential role in the Arab Spring that toppled two long-established family dictator governments and ignited at least two more attempts to do so. A huge change of pattern in communication sends shockwaves across oceans, across lands, across histories of entrenched political rule that prove no match for

the swelling tide of the people communicating with each other, making a group en masse demonstrating for the people, for the subjectness of everyone in the mass.

Yet another side of Facebook and related technologies is total lack of privacy, the invasion of personal space by mechanisms to track purchases, places visited, fantasies sought, in order to increase market value, to sell, to profit. Grimmer still is technological capacity to hack into telephone privacy to garner confidential facts of children's illnesses, grief over a murdered daughter, suffering from loss of loved ones in terrorist attacks, or personal matters of psychological, political, and medical events for gossip to raise sales of newspapers. Already, exposure of such hacking has forced closure of a gigantic newspaper that costs multiple jobs, arrest of its CEO, and resignation of the chief of Scotland Yard. At the bottom of "the lowest in you," our "incapacity," Jung says in *The Red Book,* is evil, an abyss. Here we meet the "worm" of corruption and must come to terms with it.[7]

Even our profoundest beliefs are subject to this "worm." Corruption that gets in everywhere is part of life. We remember with fresh grief the terrorist attacks of 9/11 in America and all the other terrorist bombings in cities, shops, airplanes around the world. Terrorism on that scale requires a group and a sense of the transcendent to convince individuals that they are serving a greater cause. Only that makes possible transmogrification of suicide into a weapon to murder as many others as possible, billed as noble sacrifice serving the whole group.[8] Just as personal madness bleeds into cultural life, so fear about loss of common cultural meaning exacerbates our personal fears. Think of the violence erupting at Columbine and Virginia Tech, the looting riots in Britain, the subway attacks in Japan, genocide, wars and their aftermath of crippling civilians as well as soldiers, floods of refugees with their children dying of hunger and disease. We are afraid there is no durable, dependable meaning holding us together in one world.

A Dot of Light, Healing

But perceiving this is just where a dot of light appears. To see the intersection of personal and collective madness bequeaths a small spot

of insight that radiates healing. Jung finds we get release from the humiliation of being caught in our repeated madness and the isolation our shame about it imposes on us, when we discover that our personal problem turns out to be also part of the collective problem bedeviling our time and place in culture. Some problems may even go farther, Jung opines, to connect with problems of the whole human family across cultures and historical times. Even further, our personal madness may be a tiny version of God's problems.[9]

Surrendering to being caught, held fast, demanded of by this problem, unable to solve it from our ego resources, opens us to what Jung calls the compensating work of the psyche we share at the archetypal level. Primordial images involved in this particular problem balance our being caught; they bring otherness—an other point of view, an other source of energy, an other way into the depth of the tangle entrapping us. The conversation that results between our ego and this other viewpoint yields a way through it that we could never have found or imagined. We feel then God, or something bigger, whatever we call it, has intervened.[10]

In addiction problems of our time, we can see where something other than the ultimate captures all our devotion.[11] We are held fast to a work schedule, a particular food, prayer formula, parental style that must not be breached, spellbound that this is the truth and we must not stray from it. Maybe our problem with compulsion also vexes the Holy? Is God lamenting, What am I to do with these humans who rush after their idols away from me? I flood them, I infest them with locusts, I suffer in their place, and still they run away from life with me at their center.

Acknowledging evil, at the bottom of our own madness and in our collective life together, takes us to the extreme edge of what we can bear. Shocked to discover that I am complicit in an evil I deplore, that I have done something or not done something that I never believed I could do, that I shunned as bad, I feel madness engulfs me. To see this is to sacrifice self-image, self-knowledge, self-confidence. We sacrifice our ideas of good and evil when we discover, I abet the bad I abhor. Dick Diver in F. Scott Fitzgerald's novel *Tender Is the Night* believes he is loving and rescuing his wife, his former patient in a mental hos-

pital. Horrified, he discovers she locks herself in the bathroom to get away from him. That is the only place she can secure privacy from his intrusive "goodness."

Examples abound, some unexpected. We may sink into what used to be called sloth—a letting go of our ownmost self. We slide away from finding our path, facing our problems, our creative hopes for a life that feels real and authentic. We know that we could give thought and feeling to living with meaning, but oh, not now, let me rest, let me first finish this bit of business, let me, in effect, lose my soul, as Jung did his. We betray what matters instead of living what we have not lived and could live. We want to see ourselves as kind, but we do not stop to help the motorist stranded on the highway—not enough time, we say, too dangerous, we fear, but we do not telephone for help on his behalf. We rail against a welfare system but fail to look into our financial support of our addicted son. We glimpse that we, too, are the mother who emotionally eats her children or the mother who insists on her own needs in aging over her child's need to follow his destiny. Whatever the issue, we all have one bedeviling us. In chapter 3 we look into the major complex haunting our life, which will not cease compelling our actions until we intervene. The complex, with its fanciful reiterating drama, keeps attacking as if to insist we change it before we die.

Facing Evil

Jung's *Red Book* takes us further into our madness, leading us to see exactly where we each face evil and must find the place of destructiveness in life. In doing so we contribute to the community in finding our own creative path.

I have written elsewhere how our particular temptation acts like a trapdoor hinge that opens, and we fall through it into collective evil. If we are compelled to shop, for example, and experience it as creative and life-giving, it may also harbor a secret greed or a secret insistence we must be the fairest of them all with the latest fashion. Through that hinge of overbuying we are pivoted into the morass of greed itself, having to grab more than we can use, afford, make our own. And

to get it we will step on our neighbor to seize the bargain, even cheat other customers by taking the skirt in one size that fits us and the matching blouse from another size, leaving the next customer with a mismatched pair. A small incident? Yes, but it implies a disregarding of the subjectness of others while gulping down all the goodies. Or shopping may be our hold on a creative life, without which we would fall into depression. If shopping keeps us from despair, where we live bereft of any beauty or creative combining of elements, we fall into the ruthlessness of survival instinct. I am ready to push you aside in order to live. Even if this greedy gobbling stems from being starved for love, itself a grievous suffering, nonetheless the other person is still run over, discounted. The aggressiveness asserts itself in spying the creative combinations put together in shopping. The result: a mixture of good and evil; creativity and destructiveness.

Remember, Jung learns in *The Red Book* that facing the lowest in us, we must give up the distinction of even the knowledge of good and evil: "You can no longer separate good and evil conclusively, neither through feeling nor through knowledge. . . . You can discern the direction of growth only from the below to above." This means that in our growing from the lowest point of ourselves, our incapacity, good and evil are joined, and in no other way. Once we stop growing they fall apart again into warring opposites that we project onto others to the hazard of us all: "But as soon as growth stops, what was united in growth falls apart and once more you recognize good and evil." Living our own particular paths individually and together sponsors our growth, and our growth offers some protection against evil split off from good. This astounding insight directs us to live our ownmost life that no one else can live, what Jung calls our way that we must follow.[12]

I have also written elsewhere about the necessity to "succumb in part," as Jung puts it, to such evil.[13] If we fall in entirely, we are swept into its current. If we stay high and dry, do not succumb at all, we go on unconsciously acting out our particular evil against our neighbor, claiming our innocence, and do not know anything about it. We, in effect, lie, for example, about why our group splits from your group. We do not admit it is that you hurt me, but dress up our leaving as

serving a better cause. But the spite, the bitterness, the intent to exile and never speak again speaks loudly of a jumble of hurting and being hurt under the rug between us, now built into an impenetrable wall. That kind of emotional lying we must recognize and accept in part, but not in whole, to understand our hurt, and then our hate for being hurt, then our lie as protection. These recognitions make room for mercy on how much we are hurt and want to hurt in return. Then that impulse to revenge is tempered, not acted upon. We accept the violence in ourselves, as Jung insistently urges, and do not kill our brother.

By succumbing but only in part, not being swept away by destructiveness, we give something to our community. We discover that our problem reflects the problem of the whole culture in which we live: the destructiveness facing us personally is "that voice that makes us conscious of the evil from which the whole community is suffering . . . and brings evil before us in order to make us succumb."[14] For example, our personal problem intertwines with a cultural view of the feminine as less than the masculine, a negative view that allows men to be caught in discriminating against women in sexual attitudes, payment for work, and promotions and allows women to discriminate against themselves through self-doubt and attack on their body shape. We face personal and collective shadow qualities. Yet facing the shadow also brings us the very undeveloped archaic energy of shadow contents of emerging ideas, urgent desires, instinctual insistencies to force them into consciousness. That archaic force allows us not to adapt to collective needs and values. Although we fear this *massa confusa* as madness, threatening spiritual visions and rational assumptions, the new comes in, and we need the help of the undeveloped and to feel insisted upon to become aware of it.

Behind shadow is another force, the image of *anthropos*, the whole man [sic], the whole human self in its totality, forcing its expansion on our low self-esteem, our fears, even our grandiosity.[15] All the parts, good and evil, developed and undeveloped, must come in to seats at the table, the whole of the wholeness. Our ability to withstand this influx of energy depends in large part on the anchoring of evil in something as hard as stone at the basis of us, our foundation, to see it

is part of our growing. What happens to Jung in his *Red Book* proves helpful here.

In growing we are protected from the full blast of destructiveness, because good and evil are united. This means even in darkest moments, goodness has not vanished; it is as much a part of growing as is destructiveness: "In dealing with darkness, you have got to cling to the Good, otherwise the devil devours you." Facing the destructive in us means also simultaneously holding on to the good that we know and that others give us within our culture. We thus strengthen the good's holding of us and gather into consciousness what we have been given to be.[16]

We may be surprised by unexpected goodness appearing in the midst of awful void. One analysand, caught in what she calls nothingness, looks into it and is startled by a stirring of color. She says, I see something new: a fuzz of greenness at the edges of the nothing, like trees before they bud. The analyst is able to say, The beginning of a beginning. Another example is the loss of what we believed in as an ideal, worked hard for. Utter disillusionment when others defeat it exposes us to danger of self-attack on top of loss—I should not have idealized this goal; I failed to withdraw my projection. Protecting against that attack, we may see that of course this goal failed because it is finite, a sort of God-image, an image of the good, our finite picture of the infinite. Inevitably it will wear out, not work, even if others had accepted it. It brought us this far and is not the good in itself, so of course it will decline. Can we risk a new question? What opens to show itself where this lost good object once was?

These two things—the hinge and succumbing in part—are important, true, helpful. But now something more startling comes on the scene that addresses the place of destructiveness in life and responds to our ever renewed question, Where to put the bad? Our complex confronts us with the bad we do not know where to put. And its hinge makes us fall into evil itself.

Sacrifice

Two routes lead Jung to his answer of where to put the bad. The first is to go to the lowest in himself and for all of us to go into our own

private Hell, where we are small, inferior, groping from stone to stone. There the soul lies, and salvation springs up from the discarded. We are the least among us who need a cup of water in our thirst for meaning, need clothing to protect our vulnerability. Jung's soul shows him another half of the world he has ignored, and he falls into meaninglessness, unending chaos that scatters him or sucks him into the dark abyss. Hence all his formations of the good, all that he formed as superior and best, with which he falls into identification, are mistaken. He has taken the part for the whole. He has left out meaninglessness, multiple interpretations, conflicting departure points for the sake of the one truth; he has excluded what is inferior in himself, left "at the mercy of decay" because undeveloped in himself.[17]

Step by step Jung faces each of these facts. He is not a hero; his ambition to be a prophet or a shepherd of others is self-seeking; his privileging of Logos leaves Eros in the rubble spawning secret and open vices; his relying on superiority of rational logical thinking bankrupts his feeling that presents itself at first in horrific images—mad, bloodthirsty Salome, murderer of the Holy One, and a murdered, beheaded small girl, a piece of whose flesh he is commanded to eat as an act of atonement. This is the second route to finding the place of evil in life.

It is a sacrifice imposed on us to take in, to accept that evil is something in which we collude. It forces us to recognize we collaborate with evil and to submit to the shock and revulsion this causes us. We see the injustice of our justice systems, the vice accompanying our virtue, the oppression of those excluded from our images of the good and of God.

Atonement for what? Jung knows. Even though horrified and refusing, he finally submits to the command to atone. He cuts a piece of the small girl's liver and ingests it. He knows he did not murder her, that other men did, but that he, a man, could have; he could be one of them; he could collude in the worst evil acts of humanity: "I learned that I am a party to all the horror of human nature." The one who commands this sacrifice is a shrouded woman who insists against Jung's outrage at this murder and his protest, why should he do as commanded? The figure answers, because this outrage happens every day and because "I am the soul of this child." Jung submits to the

order to atone and takes in and digests the flesh. Then the shrouded figure throws off her disguise and says, "I am your soul."[18]

This act effects in Jung the destruction of all the formations he had constructed. He disidentifies from his pictures of the good, indeed of the God. And in this seeming caricature of the Christian Eucharist, he takes in the God-image, which here is flesh of the suffering degraded feminine in its most vulnerable guise of a small girl, helpless before the depredations of men. That is the state of Jung's soul, his mangled Eros, his feeling modality; that is what his formation of God modeled on Logos, of empirical linear reasoning, left out. Eros is an equal force in life and knowledge and of feeling in his personal life that Jung must recover. The scrap of detail that it is a small girl, not a boy, and that she is beheaded indicates his lowest is the neglected feminine and that the power to think has been cut off, when in fact the thinking of so-called feeling types is profound.[19]

That evil act of neglect and viciousness toward Eros is not only the lowest point in himself but the place evil stares at him coldly. What happens as a result? All the energy that went into his formations that he identified with and that he identified with the truth—all these are sacrificed in the repellent act of taking in, making part of his flesh, this lowest undeveloped incapacity in himself, represented by the small, murdered, beheaded girl.

The Assistance of Evil

Even more astounding is Jung's recognition that he could not do this atoning act by himself. He could not eat a piece of the girl's liver: it is too abhorrent. He could not destroy his identification with the forms of life he constructed; he is helpless to do so: "Man cannot accomplish this act solely by himself, but is assisted by evil, which does it instead of man."[20] But it happens. Our formations are destroyed, not thrown on the ash heap never to be seen or used again. No. They are destroyed as the sole truth with which he is identified and which are identified with the ultimate, indeed as his images for God. They are destroyed as the "one" meaning. They have meaning but are not the only one. Whatever meaning comes in their place must now include disorder

and meaninglessness to make up a whole picture, a unity that gives a place to destructiveness in life. How does this happen?

Jung says evil does it for us, and thus we see we collude with it: we must "recognize our complicity in the act of evil; . . . the evil that I wanted performed, the infamous deed, seemingly without me and yet with me." Evil cuts the cord of identification with what we have formed as the meaning of life. Evil does it. We are helpless to do that because, I think, it feels as if we would go out of our minds. And often in *The Red Book* Jung feels loony, crazed, not knowing, not under-standing. He goes to the edge of what is bearable in that book. And remember, the time of his erupting fantasies was 160 days (November 1913–April 1914); of his writing the narrative, from 1913 to 1916; and of his crafting the paintings, to 1927.[21]

Sacrificing the ruling principle, all those constructs of meaning Jung held, is done by evil. Evil is needed to call back to us all the en-ergy we put into formations of God and devil outside us, robbing us of this creative energy. Yet "the creation of a God is a creative act of the highest love," an act of the Above. But to reclaim his lost soul, we must restore all this energy to our human life, "an act of the Below." Those powers were in Jung's soul all along but lay dormant and pro-jected out of him to make his ruling principle, his science, his faith in Logos over Eros, his image of God. Once the cord of identification with those ruling ideas is cut, and they are no longer equated with God and with meaning, all that energy streams back into his psyche and is now alive in him: "They become part of a living pattern . . . no longer dormant . . . and irradiate my soul with their divine working."[22]

His soul now gains those powers alive in him, and we will see in chapter 4 where they go (into personal life and God-making capac-ity). He is the site of transformation now; it happens in his psyche, not in a God outside him who grants salvation or a devil outside him by whom he is seduced. God lives within us, in the hut, the house, the small residence of our particular life, "like glowing coals in you . . . inextinguishable fire."[23]

We do not become God; this is not a deification of the human. Rather, "You are its tool . . . there is no escape. . . . You come to know what a real God is. The fire burns right through you. That which

guides you forces you on to the way." Another lives in us, intimately involved with us, but not identified with us. Jung objects: "The God wants my life. . . . The divine appears to me as irrational craziness. I hate it as absurd disturbance of my meaningful human activity."[24] Yet in Jung's view, we also need evil to help us do the unthinkable, the unbearable that we are helpless to do by ourselves. Something else forces us to find the way for us, a way we easily choose to avoid because it is unknown or, if known dimly, it is too much, frightening, so different from our plot for our lives.

Think of your good rules and that they must be destroyed in order to tell what really happened: he came in the night and did things to me. All the family denies it, but it is true. Something in me makes me tell what happened. I destroy my image of family harmony, his image as friendly, as landing on his feet, able to walk away; I expose his thoughtless annihilation of the other that he will not let himself know. A woman entirely devoted to her husband's schedule begins to wake up to her own preferences, as if from a long sleep, and to refuse the craziness of his diminished life, to insist on more intimacy, conversation, relaxation together. Another wife breaks out of her husband's tantrums and ultimatums, able to take them less personally, to see he is gripped by something she does not understand. Against her impulse to comfort, reason, help, grows her stand against his outbursts and for some truth buried in his anguish and anger that he must find.

A woman decides against further treatment for her cancer, choosing to make her way to live as much as she can before the terminal prognosis comes to pass. She acts against, destroys, the conventional medical view to follow some nudge into a direction that feels more true to what she has suffered physically and psychologically. For suicide has repeatedly beckoned her through her life because of lack of meaning and joy in life. Yet now, with "sure" prognosis, she feels she comes alive for the first time in a fuller way. She finds energy to move her household to another state to be near friends; she arranges her affairs and helpers in relation to her dwindling finances. She feels alive and goes on living.

A man still deeply amazed for the love found with his partner,

discovers he must speak up to his partner's occasional mocking, that they must discuss these incidents that cannot be ignored despite his dread that this may rock the boat of their whole relationship. He must name the evil with the good, Jung says, "For if you aspire only to the good and denied the evil that you committed nevertheless and failed to accept, your roots no longer suckled the dark nourishment of the depths and your tree became sick and withered."[25]

Forging Evil

But one more decisive event occurs. Jung forges evil into the foundation stone of his life. After nearly falling for the pizzazz the devil claims for himself, saying, I am "the fizz of new thoughts and action," Jung sees that is a lie. That is the seduction from the seducer of nations. The devil is the personification of all that is reprehensible in us, "pure negation without convincing force," of meaningless surging back and forth in Hell and meaningless building up and tearing down on earth. Nothing comes of it, nothing created or lasting. Jung sees the devil is the personification of evil, a "thieving abyss." Having no force of his own, he tries to steal the golden egg of the gods. But Jung smashes the lump of manure the devil hides in, rescuing the egg and then forging the devil in human form. Jung says to the devil this pivotal phrase: "You shall fit into our form, you thief of the divine marvel . . . who stuff your body with the egg of the Gods, and thereby make yourself weighty."[26]

The decisive act fits evil into human form, not us into destructiveness. Evil, though a real force in existence, is insubstantial; it seeks to acquire substance through theft and insinuation. Evil is not abolished but anchored. Where does Jung anchor it? He casts about in a vastness looking for the stone as foundation for a new beginning. He wants something graspable, not webs of confusion. He puts Satan into the stone, symbol of what lasts, is fixed and unalterable, of indestructible material, a central object in devotion. He forges the devil in the foundation stone of his (Jung's) life on which he will now stand and not fall back.[27]

What might this mean for us? It means what people discover who

work through really hard experiences in their life to a livable conclusion. They still suffer effects from that tough experience, but it no longer rules their life. The death has been made part of the living; they do not lose their life to malignant mourning. The trauma is part of them; they are not hostage to it. They accept they are a recovering addict; that scar marks them, belongs to them, but they are relieved from acting on their addiction; they are more than that scar, not identified with it. The wrong our perpetrating self did in acts of fraud or lying or cheating or even murder, and the ignorance that led to it, the venality, the bad wishing, belongs to us but does not define us; we carry it but are not locked up in it.

To free ourselves from "the old curse of the knowledge of good and evil"[28] means we hold no absolute faith in our plans for debt release, for peace, for amicable divorce but recognize the lowest, the disordered, always belongs to the whole picture and may break in and must be included in our solution. Such acknowledgment subdues our wish to make our good a fixed, mandatory certainty. It means the trauma we suffer is not erased, but we are not imprisoned in it; it lives in us, we suffer its effects, but it does not rule our life.

Over decades of clinical work I have seen this shift again and again, and it is hard to pinpoint what causes it. It is not what I have done or said, not what the analysand decides, not what we craft together; it is all of those things and none of them. Through them something emerges and summons our consent. Accepting disorientation as belonging to the whole of us gives us a booster shot to living, for behind chaos is death. To feel death's daily presence urges living to the fullest. We only have this day, even if it is the day before our death. This takes us to the second part of this book, Creativity.

PART TWO

Creativity

Compelling Complex

This third chapter begins our focus on creativity and its relation to madness. Just as madness lurks in our creativity and threatens to make dead its aliveness, so does creativity lurk in our madness. That is an astounding and heart-supporting fact. Clinical work over years brings me to see that the easiest way to get at this kinship of creativity and madness is to look into our own complex. There is one major complex that haunts our lives. It is like an ancestor that bestows on us both trouble and potential gifts. This is the central complex that overwhelms our ego's perception and functioning and bedevils us our life long. It defines the central theme of many smaller devils that we may succeed in ousting or assimilating.

Two Ideas

Most of us know this territory in ourselves (and if you do not, only ask your enemy; he or she can tell you exactly where you are caught). I am aware again that this subject causes us strain. We know this major theme sounded and resounded throughout our lives. It is our inferiority complex, or our chronic vulnerability to feeling disrespected; or our erupting anger when made anxious, causing hurt to those we

love; or our lust for power, to be the best, the hub of any wheel because we fear we have no agency. We may even have repeating images of this state of bondage: the orphan, the thug, the power-mad bully, the frightened rabbit, the betrayed child.[1]

Meditations on clinical work with the complex as a major theme in our personalities has led me to two revolutionary ideas. First: our very problem that our complex embodies and repeats becomes part of what we come to as solution to our problem. The problem that haunts me becomes part of how I resolve the problem. This insight immediately lends a more positive tone to the complex—that there is something in it, some import, that contributes to the solution of the problem. It shelters something precious that is trying to be communicated to our consciousness. How can this good be found in this evil? An example is Bion describing himself in heartrending ways as markedly schizoid, that is, emotionally distant and severely guarded. That very schizoid quality shows up in his construction of the highly abstract "grid" to track the human exchange between analysand and analyst in a clinical session.[2] The most conceptual, impersonal scheme charts the most personal, emotional exchange. Second: our problem not only forms part of its resolution, but it also shows the path to transformation; it points the way, indicates the direction to go. Madness and creativity share a kinship.

Most of us experience our complex as the problem we cannot solve, indeed, as what bedevils us, calling up the image of evil, the devil himself. Reading Jung's *The Red Book* strengthens this idea. He wrestles there with evil, destructiveness, what to do with the madness of meaninglessness his soul shows him, madness that lives in our own selves and collectively in our world. This question addresses each of us in our particular complex as the ancestor in the background of our whole lives. What is evil is no longer an impersonal question but a struggle at a profound personal level. I am struck that Jung's book is published in the twenty-first century, when we are fraught with all kinds of devils throughout the world: financial shakiness, wars erupting, sex trafficking burgeoning, dictators fighting to retain power, revolutions breaking out, joblessness, famine looming. Evil is not abstract but in daily news.

Jung in *The Red Book* displays many complexes that bedevil him. He encounters them in personified forms and gives each a hearing, usually leaving him confused, lost, wandering.[3] Threaded through all his encounters is a line that emerges as the frontier between personal and impersonal psyche. We know too that the complex that trounces us again and again often feels like an impersonal happening that lands on us. We did not cause it, and it interrupts our most personal life, causing havoc, even destruction to ourselves and to others, even our children, whom we love. The complex that trumps all our understandings of its roots in family relationships (object relations theory), traumas (trauma theory), conditioning by dominant images in our particular culture and time in history (cultural and historical theories) often feels like an impersonal happening that taxes us like an insistent unsolved riddle. That frontier between impersonal and personal psyche forms the border between unknowable and knowable that our complex keeps us crossing and recrossing.

Jung repeatedly insists we must make the impersonal personal, make it our own, see our connection to it. He says, "I know I speak in riddles. . . . I want to tell you . . . so that you better understand which things the spirit of the depths would like you to see. . . . Those who cannot must live them as blind fate, in images." Yet Jung also says, we must give up "personal striving." Paradoxical intelligence replaces intellectual intelligence. On the one hand, personal living gives color to life and makes real in time and space, place and body, what we are living, what is to be lived, and what only we can live. On the other hand, an impersonal neutrality, a kind of nonattachment, secures a sense of enduring self, saves "the immortal in me." Although a "mysterious poison has paralyzed the quality of his personal relations," he is "rich because he is himself."[4]

This topic affects clinical work and our psychological work with ourselves. The goal to master our complex is not so much cure as realignment with the whole psyche, gaining an appropriate attitude toward the unconscious. That involves a feeling sense, a relationship more than a right answer, and makes the border between objective and subjective, impersonal and personal, familiar territory.

The Complex

Complexes form a normal part of the psyche, but the ones that overtake our sense of I-ness (the ego) capture our attention, even hold us captive.[5] Their symptoms continue to interrupt our lives, seemingly without our causing them. They catch us again and again, happen to us as from something outside us. They compel our focus. We expend much energy over years to get our last foot free from the grip of our disabling complex, to understand and assimilate the guilt of breaking out destructively or breaking down internally, of causing so much trouble against family traditions, national mores, let alone stubborn moods, outsized affects, compulsive ideas, assaulting anxieties.

We suffer guilt for inflicting pain on others, for the immorality of complying with what we do not believe, for bad faith toward our own destiny. Complexes compel us to export our pain onto others and import false solutions as self-cures.[6] So we repeatedly let loose with anger, with moody condescension, with cutting off communication, with giving more than we can afford, with giving less than civility and courtesy require, with cheating on finances, swindling emotions, grabbing power, manipulating others as nonpersons.

How to find that nexus of inner and outer behavior, that interstice that grants space to find our way? The complex that will not be solved—whose traces persist in lingering symptoms of going blank, having to talk or drink or cause an escapade, or lie down in depression, or break out of a relationship because intimacy entraps us, or seize on a body problem to carry psychic conflict—may improve but never vanishes. The complex acts precisely here, like a sheepdog herding us to that space where we will not be allowed to evade the demands of a whole consciousness.

Jung's discovery of the complex from his Word Association Test, and his subsequent outline of the nature of the complex, helps us find a space between its compelling effect on us and our sense of I-ness.[7] It forms a cluster of image, behavior, and emotion that bypasses consciousness and interrupts its functioning. The interval of delay in the person's response with an association to the word reveals the presence of a complex. Thus, the complex shows its autonomy, as if it has its

own willpower and intentions to disrupt a course of action, a train of thought, a pattern of emotions. In this way the complex is like a fragmentary personality split off from the conscious I-ness of the ego that disrupts the ego's functioning, even though the ego, too, is a complex. The issue is whether we are overwhelmed by one of the fragments or we can relate to it.

We can gain a picture of our ego complex, with which we usually identify and hence do not see clearly, from how a dream displays our ego attitude. This dream-ego, as it is technically called, and which we usually presume is the same as our daytime I-ness (conscious ego), in fact portrays the unconscious view of how our ego presents itself and operates. The dream shows us our usual ego attitude as seen from another point of view in the unconscious. This other perspective inhabits our psyche; self includes other.

A complex has its own physiology as if it has a body and touches parts of our body. Some people get breathing problems; others, stomach upsets; still others, heart problems, and so on. The complex when touched speaks through our body, calls attention to its emotions and behavioral patterns by disturbing us through our body. We can go around groups we belong to and see how each person has her or his body weakness, the point of access where the unconscious complex can make its presence felt—for example, this person gets respiratory infections, that one blood problems, the other joint problems.

A complex dramatizes itself in dreams, fantasies, and hallucinations and in our writings, usually through imagery but also through pace, tempo, rhythm. For example, I tell my seminary students to look for the dominant images informing an abstract theological position as a way into the life of that theology. Tillich, for example, speaks of the boundary line as central to his three-volume theological exposition; Buber, of the "double cry" dream undergirding his I-Thou theology. In madness complexes can rend the personality into splinters of competing centers, each vying to capture the ego.

This independent other of our major complex that lives within our self pushes into consciousness with its archaic energies and contents, insisting on its recognition. Without the intervention of consciousness asking, Who are you? What do you want? Why do I keep losing

things? Going blank? Feeling fury because I imagine the other dismisses me? we remain unconsciously directed by the complex's "agenda." If we do not look into our complex, it intensifies as we age. One woman, grateful that her father found comfort in marrying again after her mother died, saw with dismay her new stepmother's anxiety about germs. She followed everyone around with detergent to spray the faucets after they had been used to wash hands. As she aged, her problem accelerated into a full-blown phobia that took up more and more time as she had less and less in her mideighties.

The Complex as Ancestor

Etymology helps. Ancestor means to go before (*antecedere*), to be a forebear, a forerunner, precursor, prototype, procreator. Ancestry brings a stock, lineage, pedigree, genealogy, bloodline, thus indicating that through the complex lifeblood flows, gathering others into our single life, endowing energy as well as unsolved problems passed on generationally. We may be carrying a complex of our parent or culture—how to recover vitality after collective trauma, from being a soldier in combat, a child of a holocaust survivor. We may find ourselves participating in a ritual of a Civil War reenactment in an effort to heal the still hurting wound of our nation.

When we look at cultural complexes, for example, that come from trauma inflicted on one group by another, we see unfinished mourning, untransformed memories, wounded parts of self and community deposited in the children of the next generation. Volkan shows that such transmission can be manipulated politically to enforce an ideology, seizing on a past trauma to legitimate a present political oppression. Slobodan Milošević chose to resuscitate anger at the death six hundred years ago on September 12, 1389, of Prince Lazar in the Battle of Kosovo between Christian and Islamic Serbians by carrying the sultan's coffin to each village to justify hostility against the present enemy (deemed the Islamic Serbians), who were then murdered in a genocide.[8]

Cultural and individual complexes blot out the specific detail particular to the individual or the group. That detail elicits our con-

sciousness to differentiate instead of acting out violence to preserve a constructed sameness of "us" against "them." We need to ask ourselves, What is the unique quality of rejection that ignites our rage in response? What are the special items that trigger our disturbance? It may be sexual theft in the nighttime that left us a mute child during the day, or weird footwork in which the other blots us out and then says, What are you fussing about? as if nothing had happened. Can we see the limitations of the other's madness and the limitations their madness imposes? The worst version, for which psychology must also answer, is the person who says, "I am sorry you experience this as upsetting, that you feel this way," but does not say, "I am sorry I upset you so badly." Psychology can collude with this evasion, as if saying, "Oh, this is from an archetypal constellation, or your projection, or by fitting you to the theory," not saying simply, "I did this and I am sorry."

In *The Red Book* Jung insists again and again, each of us must suffer our violence within ourself and sacrifice the myth of justification for our violence by our version of the good. If we do not, then we make war on our neighbor.[9] Remember, Jung was writing this during the outbreak of World War I. Here we come back to madness of the complex, for to be in the grip of a complex is to feel mad.

Repetition Compulsion

To see the major complex, like a theme of music, playing us throughout our lives, even up to death, is to know firsthand the humiliation of being caught in a force beyond our control. We dream, for example, of ourselves being chased, laughed at, attacked by aliens. In our daily behavior we perceive the same plot repeating again and again with different people, different jobs, but the same endings, the same conflict. Freud named repetition compulsion as our attempt and failure to master the anxiety of the original event that hurt and dislodged us from our identity. We replay the effort to master the pain by displacing its cause onto something else. So, for example, the student who fears he just does not have the goods, that he is missing vital talents— a surrogate here for Freud's castration anxiety and its entanglement

with the oedipal complex—shifts the flooding anxiety onto getting the paper done, a task that blows up out of all proportion and takes on a life-and-death intensity. This repeats with every assignment. Worrying over getting the work done defends the student's ego from the pain of his original feeling that he does not have the goods, of castration anxiety. This repetition holds him in its grip, but its reasons fall outside his consciousness and manifest in emotion, behavior, and image but are not represented to his ego in word and understanding. The accent falls repeatedly on the wrong syllable. The problem is with the furnace in the basement, so to speak, and he is sweating every day over a succession of radiators: Will they work? So he suffers, but his suffering goes nowhere because it is not about the real problem.

Lest we think this stubborn difficulty is confined to students, we only have to think of leaders caught in repetitions, such as Hitler acting out in his behavior and emotional appeal to his whole country his displacement onto anyone who differs from his *ubermensch* credo (the mentally ill, physically crippled, ethnically or sexually different) as the false source of what the problem is. All feelings of unease, inferiority, repressed rage, and hatred for being made to feel small, beaten by his father, can now be shouted out in parade marches, gotten rid of in concentration camps, organized into lists of extinction by displacing onto groups of people the original pain that is defended against and aimed against the neighbor instead.

Although Jung heralds complexes as the "*via regia*" to the unconscious, as the "architect of dreams and symptoms," he acknowledges that they "are so unpleasant that nobody in their right senses can be persuaded that the motive force that maintains them could betoken anything good." Jung's complexes appear as persons and speak back to him in *The Red Book*, declaring, "We are real and not symbols." He must confront them and the other points of view that inhabit him. This creates a fissure in the unity of his self. We, instead, want to get rid of our complexes, lecturing to self and neighbor to "move on" from them. Such moralizing proves feeble against the power of the complex to assert itself against our ego, for "the demands of the unconscious act at first like a paralyzing poison on a man's resourcefulness . . . the bite of a poisonous snake." But, he continues, "it is a vital

necessity for the unconscious to be joined to the conscious as it is for the latter not to lose contact with the unconscious. Nothing endangers the connection more in a man than a successful life; it makes him forget his dependence on the unconscious."[10]

We could take a small detour here and ask of our central complex: What if it is a positive one? I act the good mother, the wise one, the hero, the faithful servant; I carry on a tradition of my ancestors, or an ideal my culture endorses. Isn't this good? Yes and no. Certainly that is less painful than living in the grip of an inferiority complex, a persecution complex. But no, in that I live in the grip of behavior, emotion, and imagery over which I have no control. My humiliation is the same as from a negative complex: loss of freedom, no longer being a full subject in my own right. I live inside the unconscious instead of it inside me; I do not relate to it with all this energy inside me. I am driven to enact its agenda at the expense of my own small individual being. Think of Marilyn Monroe as a possible example. She had a genius for looking right into the camera and conveying the fantasy of sexual presence and fulfillment. It made her career. Yet her actual personal life was miserable, and she died a doleful, lonely death. In contrast, remember George Washington, perhaps the only powerful political figure who voluntarily stepped down from his leadership position. He related to his power.

Like a good dog, our complex shepherds us repeatedly into this central conjunction of conscious and unconscious, herding excruciatingly personal material together with the objective impersonal spirit of the age. When all that energy flows "back to the fountainhead" (the unconscious in us), Jung says, "That is the dangerous moment when the issue hangs in the balance between annihilation and new life." There, "pressed down to death, groaning beneath the intolerable weight of his own self and his own destiny," the crisis "is *himself*, or rather *the* self, his wholeness, which is both God and animal . . . the totality of his being, which is rooted in his animal nature and reaches out beyond the merely human towards the divine."[11]

This "intolerable weight of [our] own self and . . . destiny" destroys our conscious composure and demolishes our plans, whether from the seemingly outside random impersonal event that changes our

lives—an accident that breaks our leg, an unguessed political sabotage of our policy, a chronic national tension that erupts in the shooting of a public figure and also hits us as an innocent bystander—or a personal depression that just knocks us flat, unable to get up off the couch.

The Gap

A gap appears, a fissure, that destroys life as we have known it. As Jung says, "We are playing with something that directly affects all that is uncontrolled by man—the numinosum. . . . Where the realm of complexes begins, the freedom of the ego comes to an end, for complexes are psychic agencies whose deepest nature is still unfathomed." The complex leads down into the depth of the unconscious, like a crevice through which God can get in. In *The Red Book*, Jung shows the courage to squeeze through the rock opening only to find a corpse floating by on the water and eventually sees that this is the murder of the hero and is his complex. He is both murdered and murderer.[12]

Our repeating complex lands us in our major life conflict. Everything in us wants to resist, protest, block going into that gap. For there another way of viewing life—from the point of view of chaos, disorder, magic, our incapacity—destroys our subjective vision of how things should be. We learn firsthand the entry of what Jung calls in *The Red Book* the worm: corruption—spoiling, defeating destruction that accompanies all efforts toward coherence. We must also include disorder as real as order. We are "tutored in the pain of incompleteness."[13]

In this gap of upheaval, our complex exposes us to destructiveness in life. We meet madness. On the one hand, myriad possibilities like swarming insects blot out any order and defy comprehension; on the other hand, we are held fast in the grip of something we cannot master, entrapped in the fantasy of the complex. Analysands speak of such fantasies: I am damaged goods; I am nothing at my core; I am utterly alone; I am stained. As one analysand put it about her symptom of losing a bill or eyeglasses, she felt "tossed into the abyss"; indeed, "the most trivial loss . . . can induce the panic reaction of final irrevocable disappearance."[14]

There is a straight line connecting the neurotic complex in us to the most shocking mass trauma of cultural complex. I think of the injustice in Argentina when the Mothers assembled against the oppressive military government of 1976–83. Marching peaceably to Plaza de Mayo donned in white scarves on which they had embroidered the names of their missing children, they stood before the Presidential Palace to bring the world's attention to "the Disappeared"—their sons and daughters abducted at night, imprisoned, tortured, gone. The move on the checkerboard is the same for personal and impersonal trauma. Our subjectness is obliterated, canceled, overridden. We are rendered disposable, not a person anymore but taken away to nowhere, not mattering. The Mothers witness to the subjectness of their children, even in their absence.

Facing the gap our complex opens is grim work indeed. We feel torn away from the life we have known, cherished. Our complexes constitute splinter personalities; we feel ourselves fragmenting. Every effort to compose a foundation is littered with cracks on the surface that widen into gaps that can split us apart. If we hold to our identity with defensive rigidity, we get stuck in our own personal equation—that our view is the only view—and then foist it onto others. For example, we fit a patient to our analytic theory instead of using the theory as a guide to the person of the patient, whose particular personal details always break open the theory. Every person is the exception.

In cultural complexes, a leader can capture an idealized group self-image—of patriotism, true belief—and exploit it to inflict the group ideology on others. When in groups we take a fundamentalistic position, we feel connected to archetypal truths of precious value but rigidly enforce those truths. We have fallen into unconscious identification with those truths, so we are in the unconscious. Then we want everyone else to be identified with our views of truth, too. This is cultural madness that does not recognize other systems of meaning, other entry points to truth. Milošević was ejected from the International Court of Justice while being tried for genocide against Islamic men and boys. It was reported on radio news that he kept yelling at the judge, Who are you? You do not exist as a court; I do not recognize you.

Whether in individuals or in groups, this kind of madness stems from our being entrenched in our complex in a rigidity of subjectivity: our view equals the truth. We live in the complex; it does not live in us. No objectivity checks our identification with the complex and its version of events and people. It holds our ego captive. Its pseudo-solution of the problem of where to put the bad dictates that we put it outside ourself into the other, into the other group. We lose objective reference points that balance our unconscious identification with our complex's perspective.

The opposite can also happen and bring its kind of madness: now we lose subjectivity.[15] We lose all personal reference points that balance compliance with cultural norms, collective shoulds and should nots. We feel scattered to the winds, that anything goes. In reaction, we conform to collective standards but at the cost of aliveness and generating our own thoughts and feelings. We lose the subjective personal voice to avoid the tension of the conflict of yea and nay within ourselves. Although we comply with collective morality, that feels immoral because we do not know if we believe it. We are afraid of what others think of us or of being caught being different. But underneath we do not know what we ourselves actually believe or feel, how we want to vote. We disappear in that myriad of splinters. How do we widen space between us and our complex so a gap becomes a space where new life generates, even if we are facing death?

But on the way to such release, we feel a tornness, a sharp discontinuity. Despite our understanding of our complex, it can still assault us. Before we know it, we lose something else. An analysand beginning a session says, "I don't know where to start" and spreads out all her papers to try to make a form out of formlessness. Then she remembers a dream of having to make a presentation and not being able to find any of her notes. So both conscious feeling and unconscious dream bespeak loss of intrinsic order, delivering her into randomness. We can hear the oppressive voice of superego (and in the transference) demanding an order be achieved, but it is worse than that. Working our way down to the crevice Jung talks about squeezing through in *The Red Book*, we reach the unhinged place that dislocates her again and again. She sums it up: I have lost my center; I am splintered.

Intensity of loss threads through all these examples—loss of I-ness, balance, peace, of generative thinking and feeling. Alienated from self, isolated from others, unable to make irreparable losses we have suffered our own, we live as displaced creatures, refugees from full livingness.

Even Jung makes big strides in facing his feeling complex in *The Red Book*, so that Salome, who personifies his feeling function, transforms from an insane, bloodcurdling creature into a loving woman who wants to give her love to Jung. In response, Jung gasps with wariness and rejects her, telling her to carry her own life, not give it to him. He remembers an awful dream he associates with her, of a brass wheel rolling over his chest as he lies on a bed of metal spikes. To give himself in love would crush his freedom. Even with all the progress Jung makes, he does not find self-care married to intimate love of another.[16] I find this encouraging, that Jung did not get that far. I don't get that far either. My complex may be different, but it is just as stubborn. One awful mark of being overwhelmed by a complex is the confusion it breeds. It may sound as if I can separate deadness from loss of objectivity from deadness from loss of subjectivity, but in the moment it is usually both, and it is deranging.

Captivity

Three factors contribute to our being held hostage to our complex. First, when caught, our ego tries to do too much to get free. It does not work. Flailing about, we lose connection to the guiding instinctual base of the archetypal image at the core of our complex. We fall into identification with this archetypal energy, and it rules us; we live in it, it does not live in us. Unconscious identification with archetypal energy at the center of our complex overwhelms us with its impersonal iterations and clouds our perceptions. We thus feel defined by what our complex says, and its pumped-up force overwhelms us. We cannot find ways to live its energy in ordinary daily life. If the complex circles around an image of the betrayed child, that image dominates our ego; we are convinced that the other in the present has really betrayed us. No reasoning or attention to the present con-

text makes much difference; emotions overtake us. Some undigested personal wound from the past rises up into the present and occludes perception.

Second, as a result of identification with this splinter personality, archetypal energy has nowhere to go, no entry point into a person's life to be moderated by reflection on the context in which it is activated and in relation to our perception of the other. Complexes include personal material from our experiences growing up and cultural material from our locations in neighborhoods and time and place in country and historical era. But being driven by our complex's instinctual force, this personal and cultural material solidifies to entrench us in its narrow version of events and people or scatters our perceptions every which way, so we lose all markers and guiding instincts. Then we fall into the energy of the archetypal image at the center of our complex, feeling, for example, like the indentured servant of the mother, or, as one woman said, suicidal if her father got mad at her. She felt this is craziness. She is a grown-up woman, a parent herself, with a responsible job, a marriage. She knows this is loony, but she still believes it utterly. And I, as analyst, must believe it, lest an impulsive suicide occur. The archetypal image balloons with such power because we lack sufficient personal response to digest and domesticate its power and create meaning in relation to its force. So the energy just keeps pushing and pushing, causing reiterations of the same problem with her father.

The archetype is, so to speak, wounded. It keeps pushing in with the power of its instinctual base and spiritual trajectory because we do not give it enough space of relationship and response to particularize this energy in our personal life. This is our personal task: to grow with this good and bad and thus make oxygen for ourselves and the rest of the world. The impersonal drive of the archetypal image tyrannizes us. People refer to us as being on our hobby-horse again, Johnny one-note going on and on without relation to the actual situation, just repeating general headlines. The woman who could not stomach her father's getting mad at her had, so to speak, too small an opening to the power of the archetypal father image pressing for her individuation, her logos directing her life, her digesting all she finds

with her father to make it her own. So she both gets stuck as helpless daughter to his superior paternal power and gets scattered in locating her own fathering of her path, authoring it, begetting it.

Another example of noticing such archetypal coercion happens at retirement. Work no longer fills the hours. What needs tending stands right before us, often as a yawning gap. Is emptiness the image? We need our specific personal response to whatever the image is in order to bring into daily life what wants to be lived and what wants to let go, to die. This means we feel chaos, not-knowing, waiting as something emerges, being frightened nothing will.

The third factor that causes us to be overpowered by our complex is our neglect of one of the poles, so to speak, of an archetypal image. Archetypes are relational, body-based and spirit-aimed, impersonal and touching our personal lives. If there is an image of mother, then there is a child; a worshipper, then a doubter; a devil, then a god; deadness, then aliveness; emptiness, then fullness. Where is the other pole of the archetypal image? The archetypal image is relational in itself, with an arc from the instinctual to the spiritual. If in the grip of the instinctual behavioral repetition, such as chronic stomach cramping, then what is the spiritual meaning? Sometimes, as happens to one man, getting hold of the spiritual meaning allows him to do without medicine he has taken for fifteen years. If in the grip of spiritual ambition, then where is the grounding in the body? Which pole is missing here in our dread of retirement? Which partner is absent?[17]

Gap Becomes Space

Jung's description of Hell in *The Red Book* as endless surging back and forth with nothing much happening is a good description of being pressured by a compelling complex. Like an evil disrupter that appears active, in fact, our complex just repeats the same plot, the same ending, going nowhere. Yet our bedeviling complex also marks a path to the archetypal, and the archetypal image particular to our complex is the major introduction of what Jung calls the self to us and us to it. The complex that intrudes with only its point of view, that makes us feel caught in madness, also brings archetypal energy that

describes a path to what the self is inaugurating. The particulars of the complex—of a food problem, for example—turn up in the solution to the problem. Appetite, feeding, being fed, being fully filled and not starved nor throwing up again, but feeding to build tissues, bone, muscle, both physical and psychological, translate into a metaphor of meaning of coming into one's ownmost self, that no one else can live but us.[18] Madness links with creativity.

A patient dreamt of an amoeba-like thing that kept enlarging as it ate up bits of this and that around it. She liked this creature, was not afraid of it, was curious about it, felt that something new, completely other was taking shape, growing. We can see how we could take this growing thing as either menacing or as new life forming, again showing the closeness of madness and creativity. It is never pure this side of the grave. Even Picasso shows a mixture of pathology and genius. In a small exhibit of the women in his life at the New York Museum of Modern Art, his brilliant painterly originality shines alongside a shadow quality of displaying women as exchangeable, even disposable, objects. Rothko, in his late red period, said a painting is a communication about the world to someone else, and after this communication the world is never the same. It changes.[19] Yet his genius vied with his depression that ended his life.

Despite fear that our complex makes us mad forever, imprisoning us in sterile rigidity or scattering us into chaotic fragments, in facing it our descent can turn into quest for redemptive force. We long for another way of seeing so that what falls apart may re-form into new wholes with different levels of meaning. In that nowhere place of disruption that our complex causes, we can speak of homelessness, contingency, irretrievable losses. We see the cost of our complex: ruined relationships, others hurt, spoiled opportunities. From such grief we yearn for reintegration. Our complex forces a path, speaking for completeness, bringing us what is left out, impelling us to integrate our wholeness.[20] Like the stone the builders rejected, the complex we hate gets forged into our new foundation. It turns up in our solutions and impels us to find them.

The female executive who sought analysis because her life was "suspended" uncovered a ruling principle that had to be destroyed.

Her mother urged her always to have something to depend on of her own: money, career, a path her mother in her cultural context had to forgo in favor of marriage. Her daughter, my analysand, gained her independence but sacrificed much of the eros side of her life. Mother and daughter each took half of the whole, and the life of the whole was now pressing the daughter for realization.

Think of our own lifelong complex, which includes the good of the ruling principle that guided us and the bad of the ruling principle that excluded its opposite, which has bedeviled us as our complex. That bedeviling is our lowest point, which is also "the eye of evil that stares at you and looks at you coldly and sucks your light down into the dark abyss." We must develop the lowest in us, which means discovering and facing where we confront evil, and we must forge evil in some stonelike foundation on which we can now stand, ready for the life to come.[21]

I think of one woman whose childhood terror everyone took for granted, so my shock on hearing her mention it offhandedly, on the way to something more important, shocked my patient. All through her girlhood, every time she was alone in the house, she locked herself in the bathroom. Everyone in the family knew it; no one commented, no one discussed it. In analysis she forged that terror into her foundation. As an adult, she now lives alone and chooses to, presiding over her own grown family, having close relationships with them and her own friends, but preferring to live alone at peace.

Another woman facing chronic medical problems forges the evil of fearing no one would be with her or want even to listen to her if she was not attuning to them and making the connection work. Her serious bodily pain from medical afflictions now forces her to attune to herself first. Her body speaks the message of soul. She must face the dread of no one being there unless she is doing the work to be there for them. Her body insists she attune to her body, that she sacrifice the ruling principle of attuning always to others first. As she accepts the destruction of her ruling principle, her grave physical problems incrementally begin to improve. The evil of horror that she will not be able to cope and rise above her illnesses was second to her terror of not attuning to others, for then she faced nothing. The ruling principle of

attuning was sacrificed; the evil of facing nothing was forged into her new foundation.

How It Works

Out of the mess from Jung's hammering of Satan and forging him into the stone foundation of new life comes offshoots of Satan called the Cabiri. These are dwarfish ridiculous-wise gnomes who come like worms as "the first formations of the unformed gold . . . from the liberated egg of the Gods"; they have their "origins in the lowest" and combine two opposite vectors. They are bad and good, of the devil and the first forms of the gold of the gods. They are both "the thousand canals through which everything also flows back again into its origins" and, as well, "the juices that rise secretly . . . sucked out of inertia and affixed to what is growing." They can represent the undoing of all our doing; it just flows back, down, away into the origin places in the body, the unconscious, the unformed in culture. But they are also the canals through which all that energy is extracted from the swamp of inertia and fed into life, bringing "what is dead and enters into living." In addition, they know the chaos side of life and are sons of the devil and hence want destruction. But because they are also Jung's creatures, because he forged them when he fit the devil into human form, they are the "first formations of the unformed gold," bearing "new arts . . . from the inaccessible treasure chamber, the sun yoke from the egg of the Gods." Because of this they want their own destruction, and they want Jung to destroy them.[22]

They complete what is impossible for Jung. They haul up stone after stone for a foundation on which he now stands and that cannot be undone again. He stands on firm ground, but only if he takes the sword they offer and destroys them. They insist against his resistance, saying he will then cut through his madness and stand above his brain, free from entanglements with his formations of ruling principle, God-image, science, privileging the masculine. The psyche is not Jung's brain; it is a reality in itself.[23]

We learn here crucial things. First, that we can deal with evil once removed better than straight on. The Cabiri result from Jung's ham-

mering the devil into a human form. They are derivative of the devil, not evil itself, and also the first manifestations of the gold of the Gods. Anchoring evil in the stone makes them appear both bad and good at once. In dealing then with the bad, with the destructive, we look for the worms of the gold of the Gods and for the representatives, the derivatives, of evil, not evil itself. We learn that we find these opposites together in growing. For evil and good unite in growing. The Cabiri exert opposite pulls on us: urging us to let it all go, flow back into unconscious origins, lose what promoted us to want to give to our children, to make a contribution to others, to make love, to rise above throes of death and despair, not just to consign ourself to impotence, nothingness, doom. And yet the Cabiri also are some chthonic part of us, bits of gold, dots of light, halfanimal, halfspirit, that bring what is dead into living, knowing things we do not know, moving us to the life we can live. What I call dots of light, indicating a pathway toward the creative in the midst of madness, we might see as represented by the Cabiri's dual nature.

This sequence is hard to grasp. I will give in some detail one example, which is still a shortened version of the countless details needed. At the core of a woman's compelling complex lies annihilation. She can be made to feel she is gone, erased, no one there, obliterated. She has worked hard in analysis to locate the terrible effects of the climate of her family on her as a small girl to see the whys and wherefores this annihilation happened to her. She compensated for the lack of being connected to by looking elsewhere than to her family members for loving, being in being. She built up a life full of activities in school, then work, with friends and with sincere appreciation for the giveness of things in nature and culture. But the nonbeing, as she came to call it, attacks her over the years. This is the personal level of her annihilation complex, which, when it strikes, knocks her out, flat, a speck in outer space.

The cultural level of her complex shows the influence of the being-nonbeing theme that was a major cultural question in the West of our twentieth century: How could we come to be at all with the horrors of world wars and all the "lesser" wars that killed people and robbed them of a life of thriving. Existentialism, Nietzsche preaching that

God is dead, nihilism, secularism composed a background tonality of nothing versus something that this patient suffered personally.

At the archetypal level, the image of loving actively, of feeling gratitude for what was there, given, became, in Jung's language, her ruling principle even though episodes of falling into gaps of what was not there occurred and recurred repeatedly throughout her life over years. She worked on this. Her "incapacity," the inferior in her, was lack of assertion of her worth, of registering anger at what was denied her that warped her personality. This assertion erupted when her marriage failed, even though she, too, wanted to end it. It was not what was wrong with their relationship while it lasted those years that outraged her, but how her ex-husband treated her after they agreed to separate. Her reliance on her "ruling principle" of loving manifested in her aim to end up in gratitude for the love they had shared and in wishing him well in his life. This did not happen. Rage erupted instead, fury, imaged in connection with archetypal furies, that is, beyond all bounds, its excess in direct proportion to his wiping out that they ever had a serious engagement with each other, that she had ever existed in his life or he in hers. To her horror she was obsessed in a frenzy of wrath and ferocious vengeance. She wanted to yell, "I do too exist!"

Like any of us, when the new breaks in, when what is left unconscious finally is admitted, it roars into consciousness in primitive form, excessive, florid. She felt like a terrorist and that she could identify even with terroristic acts. The severity of her chaotic emotional and mental state deeply frightened her. She lost her ruling principle in fact, but not in mind. She still wanted to come out with loving gratitude for what life they shared and well wishes for his future life. Hence, the conflict within her kept her in turmoil, tossed back and forth between that wish and the fact of her fierce anger. She felt she was in a mad state, that the reference point of her ruling principle was gone and that the bottom was dropping out. She had no markers to contain her distress and feared she might be losing her mind.

She saw in analysis that the present rupture reopened her earliest trauma of no contact in her original family, and hence the present merged with the past, multiplying the effects of both situations, and

returned her to the unfinished task of working through lethal bits of the past. She knew she was overrun by her reactions, that this influx of archaic energies was bigger than the ex-husband's behaviors, awful as those were. She knew better and she knew she also wanted their relationship to end. So abysmal confusion piled on top of hurt and rage.

When asked what she wanted for him, from him, she always answered that she wanted him to wake up. Wake up to his obliterating behavior, his wiping out his involvement with her, deleting her as well and their relationship. That erasure touched her core annihilation complex, which he had known about. And then his saying, "Let's be friends," without any acknowledgment of this destructive behavior, enraged her. He presented himself as guileless, creditable, logical: What was she so upset about? When she asked him why he sent her a long defense of his behavior in his next relationship, which came along very quickly and quickly went on the rocks, he did not respond.

What did help her and helped me respond to her tumultuous state is related to Jung's *Red Book* experience of having to give up identification with one's ruling principle and face all it left out; for her that was the influx of aggression, albeit in archaic form. Her failure to use aggression to secure a sense of her own worth was her lowest point, and there she found evil looking at her coldly. She had not secured the value of herself. But further, just as Jung saw that he colluded with evil in the murder and beheading of the small girl and had to force himself to take that in, she had to recognize her collusion with the evil in letting the ex-husband's eradicating behavior define her. She did not hold on to her own self-definition. She had not developed in herself enough aggression to hold on to the value of what was given her to be, but succumbed again and again to annihilation of who she was. She let the ex-husband's behavior of abolishing their former relationship, and denying any destructiveness that he was doing so, define her. She saw that by letting him and his problems define who she is, she colluded with women through the centuries in not claiming their worth. That is her guilt, her participation in a collective evil. Her personal captivity to feeling annihilated contributed to a cultural evil of viewing women and the feminine as a mode of being inferior

to men and the masculine. She had to ingest that fact and digest it, that her going out of being periodically, hostage to annihilation, conspired with women being made to feel they were second class, second rate, indeed, expendable. She felt remorse in failing to stand firmly for women standing for themselves. She had let that go, let it slip out of her hands.

In addition, just as Jung recognized he could not by his own volition sacrifice his ruling principle that guided his sense of life, but in fact evil had made the sacrifice, so a version happened to this analysand. Jung's experience helped me grasp this grave event. The woman took a treasure to the jeweler to be refashioned for her to see and wear daily. On leaving home, she thought, I should put my name and address in this package in case it gets lost. But she did not do that, and the treasure did get lost. She left it on the bus and only discovered the loss when again on the street halfway to the jeweler's shop. The treasure was irretrievably lost (despite frantic efforts with the municipal lost and found department). She was devastated by this carelessness and at first attacked herself for her unconscious act. But circling around the losing, we saw that it was totally unconscious, even forewarned, but to no avail. It was like an impersonal event that had happened to her, like being hit by a car, without any of her own conscious intention, even though she was the one who had caused the treasure to be left on the bus seat.

The treasure was something she prized for herself, a thing of beauty that she loved and wanted. She saw it stood for value, her value, her enjoyment, her pleasure in existing. It stood for the precious being of herself. And it stood for herself alive in a world and as a link to beauty in the world. That is what was lost, let go of. We slowly worked on this loss—slowly, because the pain of the loss was so great she could rarely even speak of the event. It was like an impersonal happening that took out her insides. She had no insides to deal with it. It reduced her to pain. Was this an emotional memory of what had not been found in her earliest childhood—herself? Herself in a world? But the jewels were still gone. She felt carved out of her a precious something that she needed to exist, let alone to be whole as herself.

She saw that the most treasured, priceless thing had been sacrificed

and that she had not done it; it had happened. In *Red Book* terms, I saw that evil had done it and that she was complicit in letting go of her priceless worth as a human being and as a woman existing and recognized as existing in the world. This loss had happened to her as a result of early and recent trauma, but also she had colluded in it. Like Jung, she was guilty and she had to atone. The unconscious act of letting go of the treasure made manifest, in her letting go of the treasure of her ownmost self as a female, the invalidating of herself by herself and not knowing she had done it. Now she knew that it had happened to her, a sacrifice had been made to atone; that is evil doing it to and for her. That severance also secured the cutting of her ruling principle, her God-image of loving.

Loving still existed and mattered to her, and she still wanted to emerge feeling it, but it was no longer the sole ruling principle. Now aggression, hate, rage, perceiving the other's madness had to be included as well, as real parts of her life and in the life of women. She could not have reached this state by herself and done it willingly any more than Jung could willingly eat the flesh of the small dead girl. He, and she, had to submit to what happened.

In *Red Book* terms, that is atonement for the lowest in you, where she, too, accepts that she contributes to the debasing of the female, of women, of the feminine as easily misplaced, disregarded, lost to conscious, embodied living. That impersonal event she must make personal to see concretely where she participates in collective human evil. She becomes a site of the innermost, where loss and return, hollowed-outness and rebirth, happen. The complex that hounds us also bestows legacies.

Creative Legacies of Our Complex

Like an ancestor, our complex bequeaths legacies to us. It makes a path to the "unfathomable bottom," to that place where conscious meets unconscious, that nexus of meeting "that is the dangerous moment when the issue hangs in the balance between annihilation and new life," as I quoted Jung before.[24] For there we face the task of dis-identifying from the complex, which does not mean getting rid of it,

but rather getting in conscious relation with it. It lives in us; we do not get absorbed into it. We muster personal response to this repeating theme and thus gather into awareness our particular incapacity, where we are not in charge but dependent on the unconscious. Hence, the danger of being identified with a positive complex becomes clear, for we can fool ourselves into believing we do this, when in fact we are being done by it.

The complex repeats to get into consciousness, for, as Jung says in *The Red Book*, "My life wants itself whole."[25] It speaks for our whole psyche's reality and for reality outside psyche, outside forms of self and world that we have created. This wholeness Jung says is "both God and animal, the totality of his being, which is rooted in his animal nature and reaches out beyond the merely human towards the divine."[26] So the solution to the complex includes animal parts, and it asks what is the god around which our life revolves? It repeats until we receive its communication and respond to it. With luck and work, its repetition that vexed us, made us discouraged, now functions as a signal that we have gotten off course again and need to align both inside and out. By that I mean, for example, we carry the pain of being a motherless child and remain susceptible to feeling again orphaned and homeless in our world. We recognize the signal our familiar complex gives: to meet that pain and to pull it into its place inside us so it inhabits us, and we do not get lost in it. The complex also opens us into that level of pain in others, close to home and around the world and leads usually in service of some kind to the suffering of orphanhood. Or our repetition of addiction to sweets signals that our appetite for life is off center. We feel deprived of a feeding truth that nourishes us with pleasing fatness. The complex shows us where to look: to look for the truth in what sweetens. Wallace Stevens's line says it all in his discovery that imagination rules over prescribed truths, which he rejects:

> It was when I said,
> "There is no such thing as the truth,"
> that the grapes seemed fatter.[27]

The closer to consciousness the complex is, the more intense its repetitions, as if its message is about to break through, to get into consciousness what had been hiding in the compulsive reenactment. This breakthrough into consciousness shows a first legacy of our complex: destruction of an old order and dots of light indicating "the way and the bridge to what is to come," as Jung says in *The Red Book*.[28] For example, the tangle of bouts of stuffing in food and then throwing it up in bulimia, along with delinquencies, thrummed through an analysand's college and postcollege life. She sees now she was then "on a train" to nowhere, striving to take in all the "right" things to attract the notice of an absent father encapsulated in his own complex. Her frantic effort toward "success" cost feeling real in herself and cost growth from her own root. This inner loss of meaning reached outer climax in a car crash that brought all her successes to a screeching halt. She convalesced at her parents' home, and while faced with losing many teeth, an effect of bulimia, she told her parents of her eating complex and received treatment. The defeat of the complex forces destruction of meaning, hers being "on the train," and being flung off it.

But such loss makes space for findings: emptiness hides fertile seeds beneath the surface. Sensing tiny dots of light, akin to Jung's scintillae, fish eyes glistening in the dark unconscious, the analysand consents to knowing nothing yet is responsive to little intimations, whiffs, grains, traces, pointers.[29] She opened to flashes of insight, promptings of action. Recovering, she went off alone, to rely on herself, to see where in her travels she landed from her own resources. She had no map, no big plan. Like Jung in his crisis, not knowing what to do or where to go, she just did the next thing before her,[30] following a dot of light like a breadcrumb in the woods. These tiny sparks hint of possible meanings, spur body impulses indicating a direction, stir a willingness not to know but to do. The blank stare that follows destruction of our forms of meaning also neighbors a child's wide-eyed looking without preconceptions, what Jung calls in *The Red Book* an astonishing openness that he wishes for himself, a childlike mentality. These promptings are like the Cabiri, who help Jung by bringing treasures up from Below, from the dead into living. For us, we feel creative gestures toward the new that "we do not yet know" that is coming into being.[31]

psyche's complexes is a form of social action. This is not individual development, although we are changed. It is service to the whole.

Interceding or space-making works both ways—toward the unconscious and toward consciousness. Through its repetition our complex intercedes for the unconscious content sheltered in the complex. It makes space for the unconscious as if having its own right, not to be just raided to add to ego strength. Hence, our complex will not simply go away and will not behave. It insists we take notice of its communication, even if that means making a mess. Look at former congressman Anthony Wiener pressing the send key on his computer with photos of himself in his underwear that destroyed his political career and threatened his marriage. The unconscious brings a left-out, despised part and yet a weird treasured part of us to the table. If we cannot make space for it, it will break in and cause havoc.[34]

Space-making consciousness intercedes on behalf of our conscious needs, too. Our complex tutors us in long wrestling with its trigger points, constructing alternative responses to our knee-jerk enactment of it. It widens the space between our I-ness and compulsive reenactment of our complex so that we stand outside captivity to our complex, which usually goes on at the same time we stand outside it. We acknowledge the complex, feel it, name it. That makes elbow room for it. The complex goes on in us, but we are no longer entrapped in its urgencies. For example, the woman executive gets space outside her suspended state on the couch watching mindless television. Registering now hints, impulses, imaginings, she dares a new action. She invests time and money in a country summer rental to provide a space for her big dog to run and to try another way of living. This sounds small; it is, and it is large; it is stepping out of a rhythm that has held her fast for decades. It costs money, it is for her animal, literally and psychologically, and it fills with risk and meaning leaning into the unknown. The woman who could not find her papers or got lost in spilling-over papers begins to write her memoir, her own paper. These risks that are not ours may seem small, even easy; only when they are our own do we feel their hugeness, a venturing into the unknown.

Space is made for the parts of self, not rubbing out any of them

The image of dots of light is not a position paper, nor a new theory. These small points of light inspire responsiveness to look and imagine, to consent to the inclusion of contingency, fragmentation, along with reintegration. We do not reach where we belong without the long tutoring, the ancestoring of begetting by our particular complex, haunting and bedeviling, never extinguished but rearranged, anchored. Through the eye of the needle of our complex come blessings bestowed on us that leave us limping but engaged in intensified living. We create our life at the same time it creates itself in and through us.

Our complex confers a second legacy in giving a new role to our consciousness. I have called it different things: double vision and synchronistic, simultaneous, interceding consciousness. I settle for the moment on spacemaking consciousness, which is what intercession produces—space for the unbearable and for the not yet here.[32] By repetition—of forgetting things, breaking down into sobbing, breaking out in sexual escapades, risking money, risking physical danger—our complex pushes into consciousness with its archaic energies and contents. Shadow stuff takes over, all the behavior and emotions that we reject. But more, also the large psyche, the image of the whole person, what Jung calls the *anthropos*, pushes in as well.[33] This image bespeaks all that we are and all that the human is, the whole human being reaching to animal and divine.

The insistent complex badgers us until we name and represent to ourselves what presses for our attention. It is not just the other who dismisses us as of no account, who transmogrifies our gifts into manipulations to improve him or her, and who rubs us out to preserve her or his own shaky autonomy. That is shadow material that we can see clearly in the other and in which we find the pertinent applications to our own dismissals of our self, our own need to stand firmly in our own agency to say, no, these were gifts, not manipulations. Facing our shadow stuff strengthens our sense of I-ness.

The *anthropos* image brings another force, stronger and persistent. In it the whole crowd of the human family presses upon us, moving us to enlarge and house all we had excluded. Here we are not so much enlarged personally as we are connected to others, moved to find and do our small part for the good of the whole. Working on our own

but not being stuck in just one of them. We stand outside the annihilating effects of our individual or cultural complex. We do not rationalize or propitiate the god of the complex, but suffer the effects of the complex yet no longer dwell within its maelstrom. Consciousness intercedes, giving space to stand between denial and absorption, repudiation and immersion, rigidity and collapse.

Our complex gives a third legacy. It is our ancestors, like a line of genealogy. We can see it making visible major motifs as they evolve and persist from generation to generation in our immediate families and in our cultural locations. Our individuality is embedded in a kinship system. We are inextricably interwoven with each other, across family groups, neighborhoods, cultural custom, and prejudices.[35] For example, a symptom of losing may communicate that a part of us has vanished. This problem may afflict a whole family—no one found their ownmost way; they lost it, just lived with the volume turned down. One's personal vexing complex insists that you find the missing part, not let your life disappear. Hence the problem of our complex gets woven into the solution to our complex.

I think of the famous example of the great twentieth-century Russian poet Anna Akhmatova, who witnessed vanishings perpetrated by a persecutory Russian government. Held in such great esteem that government officials dared not arrest her, they tortured her through the arrest of her son. Her famous poem *The Requiem* witnesses the sufferings of whole generations of people. It begins with

Instead of a Preface
In the terrible years of the Yezhov terror, I spent seventeen months in the prison lines of Leningrad. Once someone "recognized" me. Then a woman with bluish lips standing behind me, who, of course, had never heard of me called by name before, woke up from the stupor to which everyone had succumbed and whispered in my ear (everyone spoke in whispers there):
"Can you describe this?"
And I answered, "Yes, I can."
Then something that looked like a smile passed over what had once been her face.

April 1, 1957[36]

The recent rash of powerful men in governments and international agencies accused of sexually assaulting women employees in hotels suggests that this behavior brings to light an element in them that breaks out periodically. It is as if a hidden part, discredited as unimportant and disowned when made public, insists on being noticed, even to making a shambles to get recognized by the man and by the culture. Even when the case is not clear-cut, it broadcasts publicly this missing segment, even if it is still denied privately. To grasp it is to acknowledge a gap opening in one's ego and persona displayed to the world. This gap feels like a disaster, even maybe an injustice, but definitely a mess. But it also announces an opportunity, not just how to get out of this wreckage, but to ask, What is this part of me, what does it bring? How does it belong to me, and why do I assume it is harmless? The prominence of the men ropes in a cultural and cross-cultural custom of viewing the feminine and of treating actual women as if they live at the disposal of men, to be grabbed when needed and discarded like Kleenex when used.

Analysis offers shelter to such an opportunity. Witnessing with another what the complex brings can transform the gap into a space of inquiry, curiosity, and eventually conversation. Who is this who attacks women? What relation does this part bear to my success in the world of power, prestige, and talent shown on my job? An analysand who began the first session saying he was there to grow, not because of pressing problems (a comment that alerted me to big work ahead), soon brought a dream of a killer who strapped a murdered corpse of a woman to his car to deliver to his mother. Two years later, the killer emerges as a definite personality; active dialogue begins between him and the man. The analytic container within the man and between the two of us enables this tense, violent conversation full of energy that points toward a solution. The complex, all but denied, turns out to be part of its resolution. The killer brings the energy to sustain the work to get him included. And he keeps the door open to the other half of life, as Jung says, that has no laws.

Three legacies, then, come from our complex: dots of light sketch a path through dark enthrallment to our complex; space-making consciousness intercedes for our unconscious missing bit hiding in the complex and for our conscious needs, thus freeing us from being hostage to the complex; and the problem of the complex, the killer, is included in the solution to the problem. We need the killer energy to house the complex and to gain its access point to the chaos side of life, to animal instinct and reaching toward the divine.

But our complex not only participates in solutions we reach for its devastating effects; it also shows our path through it and toward creativity. This is the fourth legacy of our complex. It uncovers the path we find and create in our wrestlings with the complex. The very fissures it creates in our surface functioning deliver us into the unconscious. We reenter its womb, bereft now of parental protecting powers, having lost meaningful prescribing traditions as surrogate parents and having lost the ordering forms of meaning we have consciously constructed. We are like a small human version of the image of the self-creating divine child; we experience rebirth from an oceanic level outside space and time: "The divine child usurps the creative function of the womb." As Jung puts it in *The Red Book*, "I am the servant of a child." With this legacy we move from repetition to creative return, the subject of chapter 4.[37]

Creative Return

The fourth legacy of our repeating complex is so surprising that it needs its own chapter. What is this rebirth like? What gets born? What is living in the space transformed from the gap our complex opened up in us? We know that the repetition of our complex is the psyche's attempt to widen the space between our ego and the complex's reiterations, to push into ego consciousness this bundle of archetypal image, affect, behavior, so we can respond to it and moderate it, get its energies into our living. The repetition is not just madness that bedevils and rends a gap into which we plunge; it also aims to expand consciousness. This happens not through conceptualization but through affective experience. Our complex intensifies in behavior, in emotion, and in dreams to cross over into consciousness. Meeting up with something powerful, both other than us yet belonging to us, imbues a sense of purpose that feels meaningful. Our flailing about in craziness yields to perception that something creative is emerging, albeit with our ambivalence. This hint of meaning rescues us from despair at being caught, held fast like a prisoner in lunacy. The madness of once again suffering the chaos of unraveling that the complex inflicts gets rescued into emerging meaning.

Rebirth

Repetition transforms into return, not a recurrent cycle always back to the same beginning again, nor a linear progression leaving the beginning behind, but a circling around at different altitudes, so to speak, perceiving from different perspectives. We trace again, for example, the original event of wounding in personal experience; in another circuit we see more clearly where a parent, confined by cultural norms, could not differentiate from such norms and hence handed them down like tablets of law. Our injury exists, but each time we compass it, come around it, return to it, while suffering its effects, we stand outside it, hence not denying it but no longer confined in it. We find and create that space.[1]

The archetype cannot be apprehended directly, but only in its effects. The young woman whose complex manifested itself in being "on the train" that brought bulimia and stealing, then, later, in getting flung off the train through a bad car accident, also began space-making to trace what started this train-going: namely, lack of any notice taken of her small girl self, no feeding her with guiding truth. Hence she gobbled signs of success she discerned as her father's fantasies and her culture's norms. Addiction to these cost her many teeth.[2] Circling around this injury through omission, discerning what was not there, a sort of shadow of nonbeing in both her parents, she strove to achieve badges of being through various culturally sanctioned accomplishments. I heard myself say, "Thank God for your bulimia," which shocked me, as it had brought great suffering to her. But her complex also spoke of soul hunger, food for soul, stolen, eaten in secret, thrown up again to ruin of teeth and wreckage of this false route. In this gap dots of light gave evidence of another path where her truth could be found. Without it the train would have taken her away.

Creative return means not an idea, not even an image, but a process that unlocks meaningfulness for us in the mystery in our daily lives.[3] The complex re-creates a hidden aspect of the emotional truth of what is going on; returning to it uncovers this truth and compensates for our ego's trying to master and get rid of the com-

plex. Instead, we unearth the truth, develop it and ourself, and grow to join its view with our view. This new mixture shifts the center of gravity from ego to Self, to use Jung's hypotheses. A new center grows in consciousness that joins parts that had been split apart.

For most of us caught in a complex, there is a component of personal experience in which some element of us got left behind, usually in some wounding of us as a child.[4] But underneath wounding lives the child's form of perceiving. It is that which we experience as reborn. Not that we go back to being a child, because now we also have adult forms of reflection and discernment. It is the connecting of the two that makes for new life: the astonishing freshness of a child's way of just being in the moment, responding with wonder, not having to get there, joining with the adult's way of reflecting on what is perceived to find mental representation for it. Critical thought, study, a functioning ego located in the world, intentions grounded in a place and time, with historical and cultural images to draw upon, have built up our adult mind. A new form of consciousness combining both modes becomes possible. It does not succumb to madness but puts it to use. Thus, we temper any ambition toward omnipotence because we are aware of the body and its finiteness, the heart and its yearnings, the spirit and its dependence on a larger whole.

We retrieve a path that seems to be emerging to find again a child's mode of perceiving without presuppositions while we bring adult deliberation to meet it. In place of repetition compulsion, we move into *complexio oppositorum*. The mark of child consciousness is openness, immediacy, willingness to give radical attentiveness to what is and is not there without foregone conclusions. The mark of adult consciousness is bringing critical differentiation to what is perceived, sifting good from bad, recognizing that not every stranger is hallowed. I remember one great-granddaughter looking at her cousin, a second great-granddaughter, both four years old. The cousin was suffering a meltdown; greatly distressed, crying, she collapsed in a heap. The first small girl showed in her face and body stillness an alert sadness as she witnessed her cousin's anguish. She saw that misery can fell us and stood quietly near her cousin, ac-

companying her in her unhappiness. A child knows what is there and not there and responds to both. We link up opposite modes of perceiving and apperceiving, beholding and reflecting. Furthermore, it is not just the joining, the *coniunctio*, of modes of child and adult perceiving, but also the *anthropos* image that lies behind the complex, urging reintegration of this child mode, pressing us to live it as an adult, to flesh out the whole psyche, all of its reality.

A bigger wholeness presses on us and makes us include what before we excluded. We might have to forgive someone whom we hate for thoughtlessly injuring us as if we did not matter. We might have to tolerate hating someone whom we would rather rush to forgive. We might have to recognize we harbor impulses of kindness that threaten to leave us open to every kind of sufferer asking for our help. We might have to see not only that we have lost our way of making a living, but also that we do not want to work at all, and then how do we find money to live? We might have to recognize we have locked step behind a group image of the right way to do things, and in fact our experience shows we feel the opposite.[5] We might have to admit we can hardly bear beauty that turns up everywhere—in trees, a child's glance, an elegant dream, a dog's furry paws—and that we duck it through texting, twittering, TVing. It is as if we live in a provincial village and discover that a big city presses to come into our livingness. Can we stand it? How do we compass it, think about it, hold it in mind, tolerate its energy in body?

Here we touch on the divine child image of the archetype of wholeness. Jung writes, "The nature of the redeeming symbol is that of a child . . . childlikeness or lack of prior assumptions . . . [that] brings with it another guiding principle in place of self-will and rational intentions, as overwhelmingly powerful in effect as it is divine.[6]

I want to say a bit more about this child consciousness. It is openness to what is there and not there; a sensibility that is beyond splits into insoluble either/or exclusions, what today is attacked as binary thinking. In contrast, child consciousness opens to infinite possibilities, multiple meanings or interpretations (as we would later call them), not as chaos but as plenty, a sense of bounty, givenness. In

such consciousness a coinhabiting of tenderness and monstrous-
ness dwell (witness children's fairy tales), awareness of presence and
absence, of body-based experiences of taking in and pushing out.
This childlike mentality reemerges from its unconscious matrix
with unending freshness. In it we feel wonder, exuberance, as well
as contemplative looking. Original thoughts and generative feelings
assemble in us, even if what we come to is already known by others.
It is our original perception, a personal inventiveness that emerges
between us and the world which is real to us and exciting. Merleau-
Ponty cites Cezanne "to say that one should be able to paint even
odors." Perception is primary, as Merleau-Ponty avers, and "the per-
ceiving mind is an incarnated mind," a "mind in its body and in its
world." These give us the real. In this perceiving lives recognition of
others, which develops into ethics: "From the depths of my subjec-
tivity I see another subjectivity invested with equal rights appear,
because the behavior of the other takes place within my perceptual
field."[7]

To be reborn in this childlike perceiving is not regression to pri-
mary process thinking, to nondirected thinking, because we bring
with it our adult capacity to reflect. We focus on selected possibili-
ties from the bounty, the plethora, and mentally represent sprout-
ing insights and thoughts, making words and finding images to give
voice to the new.[8]

That conjoining of child and adult makes the difference. This
creative child perceiving, "undisturbed by conscious assumptions,"
is markedly different from the childish, which Jung in *The Red Book*
calls "unfruitful" and "withered." In contrast is the child from whose
hand comes "everything living." Jung even says, "My God in my soul
is a child." He celebrates the fabulous names of the child god: "The
Shining One," "Resplendent Day," "the hope that enlivens the void,"
"the immortal present," "the step on the middle way, its beginning,
its middle, its end," "liberation from imprisonment," "the comple-
tion of the moment."[9]

Rebirth from the matrix of the unconscious symbolized by the self-creating divine child is creative return to the process of psyche, to psychic creativity. The child consciousness belongs to each of us. Nor is revisiting childlike consciousness a self-centered, solipsistic venture. It opens to the world and to time past and future. In the space between us and the natural, social, cultural milieu in which we live, something beckons us or strikes into our attention, inviting our response. Every child knows these moments of epiphany, in which a yellow and black spider in the middle of its web on slender tree branches solicits from us both fear and fascination. We wonder at its colored beauty, its being there. Or something we read in a book inaugurates in us a fresh departure point and conversation with the author. Or horror at the mounds of trash along the roads in a foreign country meets amazement at the bright fuchsia skirt and orange blouse of the woman bent over from the waist to tend the rice field. Or something said by an analysand in the midst of again reliving a past trauma of devastating annihilation makes an aperture, an opening in which a validating meaning is glimpsed and heralds an advent of a future. Linking to what was lost in the past resurrects, as if for the first time, what comes into view between analysand and analyst. The point here centers on the conjoining of childlike and adult consciousness that emerges between self and an other, our self and the world.[10]

In conjunction with reflective capacities of our adult mentality, our consciousness opens, I believe, to another level of psyche, beneath or beyond the chaos of tumultuous affects that Jung describes and beyond the unending instinctual conflict that Freud opined. This level of the psyche seems chaotic, meaningless to the solely intellectual perspective. Even with its possible devouring effect on the sense of I-ness, it shows itself as just all in all, what Ehrenzweig, talking about art, calls the level of dedifferentiation; Winnicott, talking about personal development, calls unintegration (not disintegration); and Jung, in his alchemical researches, acknowledges as the image-making, combining and uncombining, mythopoetic patterns of psyche.[11]

In this level of psychic creativity we experience opposites cohabiting—as Jung says in *The Red Book*, "the fullness of life, which is beautiful and hateful, good and evil, laughable and serious, human and inhuman"—and engage in what Jung found in Schiller as "serious play." Such play is serious because it stems "from inner necessity, without the compulsion of circumstance without even the compulsion of the will." Instead, "the creation of something new is not accomplished by the intellect, but by the play instinct acting from inner necessity. The creative mind plays with the object it loves." This serious play feels reinvigorating, full of the real. We create the world by endowing it with our imagining and forms; we also find the world there, given, before anything was made of it. From this space in between creating and finding we construct syntheses, narratives of our loves, histories. Marion Milner likens psychic creativity to "the lilies of the field . . . as a way psychic creativity works." Can we say the creative process is to psyche the way breathing is to the body? Wallace Stevens eschews fixity of prescribed ideas, including religion and any teleology, in favor of "the fiction that results from feeling" that registers our original perception of the particulars of reality in front of us and what we imaginatively make of them. Here again, destructiveness finds its place in life in the "primitive, forceful nature of the creative act that must ruthlessly subdue the old in order to create the new."[12]

The divine child as symbol of the new returns us repeatedly to an elemental something in each of us that can perceive naked reality and create in relation to it. Here is an image of God in the human and of the human in God, by which we can also be endlessly destroyed if we do not destroy the equation of our forms with the ultimate center of life. For then we substitute our form for that God in the central place and wreak destruction of self and others and of the nonhuman world because now we are God. In touch with this psychic creativity, with this other level of psyche in us, beneath the unconscious, so to speak, we do not equate it with the center. We become the one who attends, gazes at, glimpses, witnesses to the center, as its servant.[13] We serve the something that survives—indeed, is the myth before the myth, what precedes our beholding and creating.

Great artists speak from this space. You must have the eyes of a child to see the colors fluid and undulating (Cezanne), of the universe pressing in upon you until words catch it in poetry (Rilke). Duke Ellington, America's greatest artist, says, "The band is my instrument," meaning a tune he found or made would be improvised upon by Cootie Williams, or Johnny Hodges, or Billy Strayhorn, to return to Ellington for smoothing, extending, showing in the miniature of their musical group how creating goes on between and among us as well as within us.[14]

Repetition to Ritual

How does this happen for each of us, different from Jung but in the same pattern? If psychic creativity is a God-image for depth psychology, indicating that something elemental to the human connects us to reality out of which relation is fashioned, broken, refashioned, old forms destroyed for new forms to emerge, and that it is the going on that turns up in people's images of this central relationship—Martin Luther King Jr. speaking of going on going on—then how does this connection to reality appear in our particular lives? How do we create it and get re-created by it?

We create rituals, or rituals grow out of the repetition of our complex, that old familiar fiend that dogs us all our days. Its chaos-making churns up the compost that nourishes new ways of living with the anxiety, the depression, the food addiction, the grief that holds us fast, the trauma that threatens our destruction. Our adult mind notices a detail in the appearance of our complex that is particular to us. In that detail, that personal scrap, we find just where we are vulnerable to the old song of the complex, just where we take offense at another's behavior, just that access point where poison enters our emotional bloodstream to trigger the replay of the whole complex. It is just there, that dangerous point between new life and annihilation, that we must remark. We must give it radical attention. For there also the spark appears that hints toward a new structure, understanding, direction of living.

Finding ourselves again reimmersed in past trauma repeats its annihilating effects on our capacity to be at all. Once again we are

dispossessed of any hope to be valid as a person. Instead, we are a damaged thing, a spoiled impulse, devoid of meaningful contact with others, forsaken from the world. But even there, a faint jot, a flicker casts a new light on our old plight. Our two steps forward in recovering from trauma are countered by twenty steps backward into trauma again reverberating through our body. But the tiny dot of light reveals that the forward two steps added substance, weight, to our stance liberated from captivity to trauma. Because of that added strength from the two steps, we are able to spade up another layer of annihilation into reparative imagination. Such a dot of light sponsors our creative gesture toward building something new. Just there we dip into the unconscious matrix to destroy the conscious composition of the complex that binds us, to surface again with the start of a new gestalt in the making. Destructiveness finds its place in our life.

Our choice is involved as well in the emergence of ritual from repetition, of creative return from compulsion. Sometimes the choice is outright, such as going into analysis with all its rituals of time, place, fee; looking into fugitive thoughts, missing memories, dreams that surprise, coming like bulletins from a self we didn't know. Sometimes the choice is a barely discernable shift of posture, a leaning toward perceiving the light and staying there with it, or a momentary certainty we must accept the dark, for it has its life, too. Sometimes the choice comes from a daring to trust that the body has resources, the psyche too. We cannot solve this, but something in us, through us, coming from somewhere else arrives, and we trust it to see us through. The choice is to stay true to the truth of what we experience, with faith in resources from within and from without. Sometimes the choice is an all-out response to the numinous that arrives, and convinces, and lasts through reflection and critical examination. Sometimes the choice opens our heart to the world, an *amor mundi* in place of an *amor fati*. We love the world and others in it, including colors, music, trees, animals, courageous souls in history, as well as our own neighbors.

Examples are countless in as many variations as we are to each other, each playing the same theme in our particular way. A woman

identified with being a mother both literally to her daughters and figuratively to the world in her work, for whom maternal giving was her ruling principle, left undeveloped her own growth and assertion of what she wanted and needed. At the bottom of that lack evil stares at her coldly. How should she forge it into her foundation stone for her life? In the brutal attack of cancer in herself and in one of her daughters, too, this process of facing and forging fell upon her, breaking her identification with mothering. For she was helpless to save her daughter. Her mothering was not omnipotent. She could not protect her daughter as every mother seeks to do; her daughter died while she lived. That trauma broke her identification with all things maternal. A new meaning emerged between them during their treatments for cancer, a form of closeness as two women carrying the burdens of illness, as two sister sufferers facing death. This new axis destroyed the parent-child one and made room for them as two beloveds helping each other.

Repetition gives way to ritual that includes the complex but breaks through its bounds. It is other people's repetitions that seem ridiculous to us; we want to urge them to get over it. It is our own repetitions that require all our effort to admit the large revealed in the small. Jung says in *The Red Book*, "I had to swallow the small as a means of healing the immortal in me. . . . I resisted recognizing that the everyday belongs to the image of the Godhead." Our conflict between our conscious viewpoint and the unconscious working of the complex continues. The complex behaves like an antagonist who thwarts our understanding of what is going on, despite our intellectual map for it.[15]

Active engagement with these opposing views helps a lot, as we grasp more deeply that we hold at once two rivaling moves to action. Such understanding enlarges the space in which we live but does not stop our being flung back and forth between the conscious and unconscious poles of what grips us. We are also helped by discerning what the complex has sheltered all these years. In my experience a piece of aggressiveness always hides in the complex that has not been lived and may be lived now.[16]

The ritual that emerges, however, is what changes the whole landscape. The suffering of the complex as it destroys the meaning of our now dethroned "ruling principle" gives way to a new sense of meaning: what our form of service is going to be. There are many case examples of these moving transformations that involve countless details to communicate and hence cannot be included here. What enables the ritual to take concrete shape in a person's life is the discovery of what they venerate, finally what they serve.[17] This is not so much a choice of exerting our will to do that as it is an uncovering of what summons our passion. The ritual evolves as our form of response to what unfolds as vocation. Two vectors then present themselves: our personal life and our god-making capacity.

Personal Life

Living our actual lives here and now with all their troubles and simple happiness in being becomes the site of transformation. Here we come to terms (or fail to) with destructiveness as it assaults us from outside in such things as market recessions, joblessness, illness, war, and the indifference of insurance companies and from inside in the violence we keep exporting instead of wrestling with as our own. Our complex bridges inside and outside by erupting into the world to bedevil friends, family, and coworkers and by laying waste to inner peace and fruitfulness. Our complex becomes the site within the site of transformation or its failure. Our complex is both our madness and the scene where dots of light appear. Jung writes, "If I accept the lowest in me, I lower a seed into the ground of Hell. The seed is invisibly small, but the tree of life grows from it. . . . It is forever about beginning again down where nothingness widens itself to unrestricted freedom."[18]

Connecting to child consciousness within us gives access to psychic creativity. Child consciousness, which is perceiving without authorized assumptions from a space of beginning before beginnings, not yet fixed in exacting patterns, opens to psychic creativity beneath the unconscious of instinctual conflict and of chaotic af-

fects. In psychic creativity flows a kind of peace that mystics speak of, an imaginal interpenetration of reality and image of reality, fiction and fact, inner with outer, that liberates us from fixity of any teleology.[19]

This experience is so rousing and endearing, for here oppositions meld to grow together in unity ("I am smelt anew," as Jung said he was[20]). For example, the big distinction of good and evil that falls apart into hostile strife the moment we stop growing, if we are growing, shows the kinship of madness and creativity. A path unfolds that allows for meaninglessness along with meaning, destructiveness along with building a life.[21]

That other half of life—chaos—must be included because it exists, too, and is not just tolerated but accepted as part of the whole. Jung asks, "What is there, where there is no meaning? Only nonsense, or madness." And his soul answers, "Nothing will deliver you from . . . meaninglessness, since this is the other half of the world."[22] That indicates, for example, that we stand right there in our fear when our particular madness threatens, or the madness of our group. Giving fear a place puts fear in its place, a place in the status of the whole self. When we rigidly defend against fear, it must overwhelm to get a place in our emotional economy. It exists, and it is our job to find where to put it lest it puts us.

Giving hate a place connects us with energies that defy the force in the other or in the world event that would crush us. Hate galvanizes intense energy to assert that we exist and have not been destroyed. Accepting its energy means holding it, surviving it without inflicting hate in return on the other, not acting out destructiveness. In time, all we value will be destroyed in death. Our task is to do with full heart, soul, mind, and strength what is our part to do. As Philemon, Jung's guide in *The Red Book*, says, "man is a gateway." Transformation, if it happens, happens here between us and in us. For Jung, in that volume, this is the individuation that takes place in the human.[23]

For this task we need devotion strong enough to surmount the resistance we feel and what Jung describes as his nausea, horror, defiance, brooding gloom. We return to the nowhere in us, where the

complex delivers us, paying close attention to the scrap, the detail of how exactly our foot gets hobbled, and taking seriously, as Jung says, "every unknown wanderer who personally inhabits the inner world," giving "due attention to everything that crosses your path," looking into "everything in your Hell that excites your contempt or rage," and engaging "the utmost concentration of expectant attention." This is how "you make yourself into . . . a vessel of creation in which opposites reconcile." Thus, we also serve others: "If we are in ourselves, we fulfill the need of the self, . . . and through this become aware of the needs of the communal and can fulfill them. . . . Then the life of God begins. . . . May each one seek out his own way. The way leads to mutual love and community."[24]

It would not be accurate if we did not also note that we can say no to taking up our own life. We may shy away from it, refuse it outright, refuse it by playing at it but in fact closing up against any transformation. We do this; many times we settle for this. We just brush by our complex and its eruptions and thereby force our children to do the same, to walk around, even on tiptoe, Dad's repeated temper, Mom's repeated lecturing how things should be. This looks like acceptance of the complex; it is not. It is avoidance of dealing with what is under our nose. We let each other down by letting each other get away with this evasion.

We in our smallness, where repetition compulsion transforms into creative return, are the gateway, the location where whatever happens, happens. We come around again to the bad and vexing, both individually and culturally, to spy the way that can only be seen there in the nowhere place, to submit to what holds us fast, to hear its communication of what must be included.

Jung chooses to experience the complex that confronts him in many guises. He lets himself have the experience of his madness, and what acceptance of it requires of him. He submits to what presents itself, not trying to impose premature resolution. He overcomes his previous power fantasies, forfeits illusions about himself, gives up his ambition to be the hero, the prophet of the new, the shepherd leading sheep who are less than the shepherd. He ends up in his garden, tending his own life.[25] He accepts the

limits of his madness, that he can go so far, no farther, for example, needing to choose freedom over love with Salome; they do not go together for him. He sees he must return again to the Middle Ages to find a creative solution for the barbarian in him.[26] Indeed, the book breaks off midsentence with no final conclusion except that he is led to a new way to pursue what he records in *The Red Book* visions.

The dots of light sketched a path into research, now into materials that involved not just his individual experience but that of many minds, many people's fashioning of their responses to the work of creative return. He turns to alchemy and to comparative research of myths and religions to discern the workings of individuation. He feels this route is now more productive than trying, as he did once, to resume the adventure of *The Red Book*. The creative opened from his personal problems into service of the whole: "There were things in the images which concerned not only myself but many others also. It was then that I ceased to belong to myself alone, ceased to have the right to do so. From then on, my life belonged to generality. The knowledge I was concerned with, or was seeking, still could not be found in the science of those days. I myself had to undergo the original experience, and moreover try to plant the results of my experience in the soul of reality. . . . It was then I dedicated myself to the service of the psyche."[27]

For us in each of our lives in our own times and places, the task is the same, to live our ownmost life, not someone else's but what comes before us. Jung is insistent in *The Red Book*: "Who should live your own life if not yourself? . . . There is only one way and that is your way. . . . No other way is like yours. . . . You must fulfill the way that is in you." And though we share the same kind of mental life, we do not share the same mental life. So Jung cautions against imitating his path, even saying it can be an obstacle to our path. And further, we find our way only "by living your life to the full. You live your life fully if you also live what you have never yet lived. The life that I could still live, I should live. . . . The thoughts that I could still think, I should think."[28]

All this falls to us to meet and do—to make the impersonal

events personal, to let go our own illusions and power trips, to find and tend our garden, to find the immortal that nonetheless lives in us, for "only my life is the truth . . . we create the truth by living it."[29] Investing in our own way, we serve the whole; a path eventuates where we take up our individual service to the whole.

It can be frightening to discover our life matters in the ultimate scheme of things, even if we do not know exactly how; it places upon us ability to respond, responsibility. We live under regard, recognition. But by what? By whom? Here we come to our god-making capacity.

Our God-Making Capacity

The ritual that replaces repetition of our complex circles around that elemental something we venerate. That reference point is there whether we acknowledge it or not; it is what acts in us like a center around which the rest of us revolves. Our complex makes its form evident. The food addiction, for example, reveals what we think of all the day, argue with, resist, surrender to, as if a deity we worship. The same with inferiority, or power, if that fuels our lifelong complex; its dominant image acts like our directional compass for the universe in which we live.

The archetypal image can be positive: love of our child, partner, work, country; our cause of justice-making; our devotion to simple acts of kindness, nature's beauty, music; our belief there is no god but instead imagination, enigma. With luck this image that acts like the centering reference point brings vitality and joy. I remember a patient long ago telling me of her discovery as a teenager of rock 'n' roll music and Elvis Presley. The sheer rhythm and beat of the music moved her body, counteracting the sharp attack on her budding sexuality by her mother (soon to be transferred to me). Such vitality in body, opening to jubilant sex that sabotaged the strictures mother's voice imposed, not only compensated the straitlaced ego recommended to her, but opened a portal to the wide world, a joyous being in movement through body sensuality.

The madness of being identified with the archetypal premise of

our complex also contains our creative power to venerate something elemental that includes meaninglessness in its meaning and beckons us to return and circumambulate it to uncover and name it. Failing to do that living of our own truth leaves us under the sway of our complex. I know women in their eighties still worrying if they are thin enough.[30] Old age is hard with its physical and mental crumblings. We cannot just go to bed anymore, but first must do more and more things—for teeth, eyes, joints—but if we are still under the sway of the complex, it is harder still. The bill comes due before we die, to finish the unfinished work. Our complex intensifies as if now barking and biting at us to get us to deal, engage.

By god-making capacity I mean the fact that we do center around something that acts as if it is a god to which we devote time, energy, and effort, whether in the madness of our complex or in the freedom of veneration. My garage man gives an example. At the annual pizza party men bring the old cars they have rebuilt, painted, shined, perfected in engine and styling. These gems are parked out for all to see. I feel I am in a monastery beholding sacred objects to which literally a thousand hours are devoted to honor the invention and reinvention of these machines of power and beauty. You might object and say these are idols. Even if so, the idols function to draw our gaze to something transcendent. The patience, the discussion of methods of care, the daily voluntary giving of self to this work of creative restoration speak of their gaze being drawn toward something that matters and confers on the men relation to it.[31]

Remember my thesis: our problem shows up in the resolution of the problem, and more, creativity generates pathways through our problem; our problem itself opens the pathway to its transformation. For me, after decades of work with psyche, madness and creativity share kinship. I find this hopeful. A sustaining passion in my work as an analyst is to see how this happens in each person's case. Another terminology might be to say that our human symbol-creating power to create images of what matters connects us to what matters. Yet those images do not lie solely under our power. They arrive; they surprise; they are foreign, not invented by us, yet make us feel deeply recognized. Jung says, "Shouldn't we rather let God

himself speak in spite of our only too comprehensible fear of the primordial experience? I consider it my task and duty to educate my patients and pupils to the point where they can accept the direct demand that is made upon them from within. . . . I have gained a deep and indelible impression how dreadfully serious an experience of God is." And further, "It is not a matter of indifference whether one calls something a 'mania' or a 'god.' . . . When the god is not acknowledged, egomania develops, and out of this mania comes sickness."[32] We must note that this experience is for God's sake. Repetition gives way to ritual, which bespeaks service to others and to Otherness that is never domesticated into human terms. This is not self-realization, though that may be a by-product. Attention focuses on what is, on its behalf, there; there it is and I am witnessing it. That is the veneration, a cherishing.

The catch is how to get it into our life, how to move out of repetition compulsion into creative return, turning around the complex, as that which crosses into visibility and invites our reverence. If we only have an idea of it, even a formed intellectual understanding, the god stays out of our life, or we out of it; it is a theory, a concept, however fine, but not the coin of life. How to get our madness to work for us, to put it to use. When that happens we enter into multiple instances of conversation—between us and what comes through our unconscious, between us and the analyst if this happens in analysis, and between us and the other of the artist or teacher or text or Scripture or poem or jazz or car that bespeaks this venerable reality.[33]

We could say Jung sees psyche as a means of access to what transcends it. For Jung it was crucial to find his contribution from his human side to this conversation, not to comply with inherited dicta he should believe. He says he lacked the gift of faith, and his writing conveys the idea of a faith as blind, even coercive. It was not a fructive, fertile, engendering ground for him. Indeed, the ground for Jung included the unconscious, which is unknowable. Hence, ground included groundlessness.[34]

Is the creative psyche, then, the God-image around which depth psychology circles, offering a housing of the unknowable within the

knowable category that must be lived to be grasped in its vitality? This view grants protection against rigidifying reification that is associated with religion as superego pressure. But still, this is a God-image. Can we risk a religious daring to ask from whence comes the creative psyche? Who is its author? Its source beyond us? For we find it, develop it, but do not originate it. We do not make it, though, as Winnicott notes, we facilitate its recognition in personal relations and in cultural locations.[35]

Here we move into great darkness, celebrated by Gregory of Nyssa and Bernard of Clairveaux as the acme of religious knowledge that dissolves into relationship with the Source beyond our knowing. Bion writes of proceeding from darkness by way of darkness into darkness.[36] Alone and together each of us must answer what is Source beyond Source. Our creative psyche makes a diamond net of associations gathering a multitude of dots of light into a whole constellation that includes us and others together as creators, helpless victims, sufferers of the unspeakable, and victors over shame and hopelessness. The psyche offers portals through which come love and wiseness.

But in *The Red Book* Jung had to fight to do this. And he would say we all must fight to get our self free from God. He means by this, God is not the self, but behind the self, and, uniting with the self, we reach God. His struggle was to own his own self and soul and then give it to God. We must wrestle God for the self because he (Jung) had not been with the self, and it was left in God; and God, who also includes meaninglessness, hate, powerlessness, by sheer force just sweeps away the self. So we must free the self from God so we can live. Jung had lost touch with his soul, and the whole book is about finding that soul and what it shows him. He has to get his soul for himself and his self in himself. Then he returns to God: "I believe that we have a choice. I preferred the living wonders of the God. . . . I cannot deny to myself the experience of the God . . . since I want to live. My life wants itself whole." Jung wants to feel his freedom and his own force, not have it all lodged in God, but to live it from within himself.[37]

The same issue of freedom versus intimacy with Salome had

come up for Jung, and he found them incompatible. Jung does not solve this opposition. He urges Salome to carry and live her own life, not to give it to him. He values his freedom more: "Love would bind me like an iron ring that would stifle me." Now he wants his soul to return to him the precious love and not make man labor for the soul's salvation but let the soul work for "the earthly fortune of mankind." He wants the treasure of warm human love for himself, not in the hand of the soul giving it through him, but his to give: "Love belongs to me." He solves the Salome problem of love of another versus freedom for self by voluntarily submitting to love itself (not to a person). Similarly, Jung must know his own free will toward God, his own self distinct from God. He must not submit in blind faith, but gain his self separate from God and then choose God. He recognizes that "one does not live one's self; one is lived by the self; it lives itself." However, Philemon, Jung's guide through the book, then tells him "to enter even deeper into God," and Jung encounters Hap, the lord of the frogs, of "the bodily juices, the spirit of sperm and the entrails, of the genitals . . . of the joints . . . of the nerves and the brain . . . the spirit of the sputum and of excretions."[38]

Jung gives the name Abraxas to this God behind the Godhead that includes Hap, the lord of the frogs. Abraxas is "the creative drive . . . form and formation. . . . Abraxas produces truth and lying, good and evil, light and darkness, life and death in the same word and in the same act. Therefore Abraxas is terrible." In relation to this life force our human task achieves distinct personal life via individuation, for "our very nature is differentiation." If we are true to our essence, we differentiate, and "the primordial creator of the world, the blind creative libido becomes transformed in man through individuation, and out of this process [comes] a divine child, a reborn God, no more dispersed . . . but one and individual, and in all individuals . . . actually born in many individuals but they don't know it, a spirit in many people, the same everywhere."[39]

Philemon says that Christ's work would be completed if "men lived their own lives" as Christ lived his. But instead, they make demands on Christ "and still ask you to take pity on them and beg

for . . . the forgiveness of their sins through you. . . . Men are still childish and forget gratitude, since they cannot say, Thanks be to you . . . for the salvation you have brought us." Philemon says to Christ, "The time has come when each must do his own work of redemption." And Jung responds full-heartedly: "I decided to do what was required of me. I accepted all the joy and every torment of my nature and remained true to my love, to suffer what comes to everyone in their own way."[40]

Each of us makes a similar but not identical decision when we wrestle our compelling complex to fetter its bit of evil in the foundation of our life. This means living with the scars and effects of the complex—the trauma that can still bleed, the inferiority that can still burst on the scene, the remnants of betrayal that can still excite us to violent ultimatums. We recognize that evil bit as our potential to participate in violence in the world. Yet wrestling thus with its compulsion can transform into sustained return to the creativity lurking in the madness of our awful suffering and behavior. Those dots of light that sketch another path lead to our particular kind of service to the whole.

We do not encounter Jung's figures of Hap, Abraxas, Christ, and the divine-child image. We have our own encounters, such as, to cite analysands' experiences, the whale scarred and wounded, the deer, and the child left in the crib in a strange place, or the fetish object at the opposite end of a mandala vision whose compartments of colors align with directions of north, south, east, and west, creating an order that surpasses the lure of the fetish. Or we have theoretical glimpses of the whole: that the self, in Jung's vocabulary, is both multiplicity and unity and can be conceived as "a space of openness" rather than pinned to a specific definition. Philosopher of religion Richard Kearney proposes a "fourth reduction" (in the history of phenomenology) that opens a free space where conflicting beliefs can converse. This space does not belong to an elite but to all of us, as if the absolute needs to dissolve itself provisionally into a moment of nothing to return to itself in the simplest of things, in ordinary finite daily events. Speaking of the freeing effect of analysis with Bion, a man says, "I found that utterly miraculous and some-

thing for which I feel eternally grateful. . . . My mind was amazingly open to invitations that I had never been able to have before."[41]

Difference and Unity

I think of the juxtaposition of the Tower of Babel story in the Hebrew Bible and the Pentecost story in the New Testament. In the text, following the flood and God's covenant with every living creature never again to wreak such destruction, the "children of men," who speak one language, decide to build a tower "whose top may reach unto heaven" and "make us a name, lest we be scattered abroad upon the face of the whole earth" (Genesis 11:4). But the Lord saw "the people is one; and they have all one language . . . and now nothing will be restrained from them which they have imagined to do" (Genesis 11:6). The Lord confounds "their language that they may not understand one another's speech" and scatters them "upon the face of the earth" (Genesis 11:7–8). Sameness as identity, oneness as uniform, as invariable, is not to be, but is broken up. In psychological terms, falling into unconscious identification with one's point of view soon becomes prosecuting one's view as The One, an equation of our view with the truth, the real, the good for everyone. Feeling connected to archetypal reality and what comes through it of reality itself feels like being plugged into what matters, what lies at the center of everything; it comprises a great treasure. But then equating our experience of God with God, lest we lose it, be scattered, no longer in this certain oneness, displays power creeping in against fear. Then we seek to dispel fear by all becoming one, which means to have power over others and to be God. As the text says, nothing then restrains us or our imagination of what we can do. We dictate who lives, who dies. That is omnipotence, an attempt to control good and evil.

Pentecost shows the opposite (Acts 2:1–8): "Suddenly a sound came from heaven like the rush of a mighty wind." The Spirit descended on everyone present, "and there appeared tongues of fire resting on each one of them . . . and they began to speak in tongues as the Spirit gave them utterance." Hearing the commotion, many

men who had gathered in Jerusalem "from every nation under heaven," drew near and were "amazed," because each one heard them speaking in their own language. The locus of power remains in the Holy Spirit, not the mortals. They join together in that presence, not in all becoming alike, but in all the individuals becoming united in looking to the same generating source. They are different, yet in a moment of unity, multiple, and yet for a moment in oneness, looking to the same beginning and end point. This communicates a vision of place for difference and unity granted to us, not owned by us—momentary, not fixed. We recognize each other's God-images and their connecting ability to what lies beyond them. That is how churches, mosques, synagogues, sangas are created. People gather together around a vision of that elemental something in which each partakes. Yet sustaining that vision depends on not closing the space of differentiation of each from the other, so each has her or his experience of what that vision is and room for it to be held in the common container, making room for each one's madness, so to speak, and putting it to good use as nutriment for the health of the whole. An equation is not sealed. Open space preserves the space for all. In this story sameness and difference abide together.

The point is that we all revolve around something elemental that functions as a center even if we do not accord it reverence. The brunt of Jung's *Red Book* moves us to name it to ourselves, pushed by our major complex to surmount its compulsion by circling around its communication to get creativity hiding there into living. This is our God-making capacity. To know it frees us, makes a passage for the energy of the original experience of connecting with truth to flow over into life. But how do we give heart, soul, mind, and strength to the source and object of the beginning and the end of this experience when we also know, and our complex daily reminds us to know, that we are finite, that our images bring the peculiar standpoint of our limited perspective? We cannot know if what we call truth is universally so for everyone for all time. For us it may be true, and this is the experience of mystics and those grounded in life-giving religion.

We face the paradox of full-out commitment alongside not-

knowing, and yet we do know, and yet we do not know. We cannot close that space into an equation. Psychic reality, reality of the unconscious, even the astonishing freshness of psychic creativity display the ever-changing images of the center of the All. When we fasten on one definition, we close from our side the openness of the I AM to reify a single name for this reality, and the worm of corruption comes in. For now we want to dictate to all people for all time our version, to make our small into the large.

Can we know then anything for certain? Yes and no. Yes in that the heart is moved and pours out in responding love and awe; no in that we cannot prove nor prosecute this truth. We can point, image, symbolize, experience its sacramental presence, offer our intellectual thinking around it, our sensuous making of representations of it in our imaginations and in our arts, our words; we can love it, as Augustine says, and let it do what it will. What makes truth vivid is living it, serving the whole through it.

Notes

Series Editor's Foreword

1. W. James, *The Varieties of Religious Experience* (New York: Penguin Books, 1982): C. W. Beers, *A Mind That Found Itself: An Autobiography* (Pittsburgh, PA: University of Pittsburgh Press, 1981); J. Hillman, *Suicide and the Soul* (New York: Harper & Row, 1964); W. Styron, *Darkness Visible: A Memoir of Madness* (New York: Random House, 1990); K. R. Jamison, *An Unquiet Mind* (New York: A. A. Knopf, 1995); K. R. Jamison, *Touched with Fire: Manic-Depressive Illness and the Artistic Temperament* (New York: Free Press, 1993).

2. S. Marlan, *The Black Sun: The Alchemy and Art of Darkness* (College Station: Texas A&M University Press, 2005); B. Bowen, personal communication, 2011; D. H. Rosen, *Transforming Depression*, 3rd ed. (York Beach, Maine: Nicolas Hays, 2002).

3. V. Kast, *Joy, Inspiration, and Hope* (College Station: Texas A&M University Press, 1991).

4. E. Levinas, *Ethics and Infinity* (Pittsburgh, PA: Duquesne University Press, 1985).

Introduction

1. C. G. Jung, *Mysterium Coniunctionis*, vol. 14 of *Collected Works*, paras. 42, 45, 49, 50.

2. C. G. Jung, *The Red Book, Liber Novus*, ed. Sonu Shamdasani, trans. Mark Kyburz, John Peck, and Sonu Shamdasani, pp. 231, 235.

3. Ibid., pp. 246 and n163, 247 and n164, 254 and n238, 255 and n240.

4. Ibid., p. 219, frontispiece. See also C. G. Jung, *Memories, Dreams, Reflections*, rec. and ed. Aniela Jaffé, trans. Richard Winston and Clara Winston, p. 192.

5. C. G. Jung, *Letters*, vol. 1, ed. Gerhard Adler and Aniele Jaffé, trans. R. F. C. Hull, 5 October 1945, p. 384. See also Ann Belford Ulanov, "The Holding Self: Jung and the Desire for Being," chap. 4 in *Spirit in Jung*, p. 78.

6. Jung, *The Red Book*, p. 229 [emphasis in the original].

7. Ibid.

Chapter 1. Personal Madness

1. My analysands who permit me to cite their words and experiences have richly contributed to this writing and to my perception and thinking. I offer my heartfelt gratitude to them for teaching me.

2. C. G. Jung, *Memories, Dreams, Reflections*, rec. and ed. Aniela Jaffé, trans, Richard Winston and Clara Winston, p. 178.

3. C. G. Jung, *The Red Book, Liber Novus*, ed. Sonu Shamdasani, trans. Mark Kyburz, John Peck, and Sonu Shamdasani, p. 235 [emphasis in the original].

4. For further discussion of Jung's notion of healing, see C. G. Jung, *Letters*, vol. 1, ed. Gerhard Adler and Aniela Jaffé, trans. R. F. C. Hull, 10 July 1946, pp. 428–29. See also C. G. Jung, "The Tavistock Lectures," in *The Symbolic Life*, vol. 18 of *Collected Works*, paras. 231–33, and Ann Belford Ulanov, *The Unshuttered Heart: Opening to Aliveness and Deadness in the Self*, pp. 196–99.

5. Jung, *The Red Book*, p. 322.

6. D. W. Winnicott, *Playing and Reality*, p. 97.

7. Eric Brennan, "The Recovery of the Lost Good Object: The Conflict with the Superego," chap. 8 in *The Recovery of the Lost Good Object*, ed. Gigliola Fornari Spoto.

8. C. G. Jung, "A Review of Complex Theory," in *The Structure and Dynamics of the Psyche*, vol. 8 of *Collected Works*, paras. 198–204.

9. C. G. Jung, *Modern Man in Search of a Soul*, trans. Cary F. Baynes and D. S. Dell, esp. chaps. 10 and 11. For examples of other descriptions of the "gap," see such authors as Michael Balint, *The Basic Fault: Therapeutic Aspects of Regression*, chap. 4; Thomas H. Ogden, *Reverie and Interpretation: Sensing Something Human*, pp. 3–4, 124–218; D. W. Winnicott, "Ego Distortion in Terms of True and False Self (1960)," chap. 12 in *The Maturational Processes and the Facilitating Environment*; Nathan Schwartz-Salant, *The Black Nightgown: The Fusional Complex and the Unlived Life*, pp. 1–3, 13–14, 63–64; Sue Austin, "Jung's Dissociable Psyche and the Ec-static Self," *Journal of Analytical Psychology* 54, no. 5 (2009): 581–601.

10. Melanie Starr Costello, *Imagination, Illness, and Injury: Jungian Psychology and the Somatic Dimensions of Perception*, pp. 4, 98.

11. Ibid., pp. 5, 112.

12. Ann Belford Ulanov, *Attacked by Poison Ivy: A Psychological Understanding*, chaps. 3 and 4.

13. Sue Grand, *The Hero in the Mirror: From Fear to Fortitude*, pp. 132, 136; Schwartz-Salant, *The Black Nightgown*, pp. 143–44.

14. Ann Belford Ulanov, "When Religion Prompts Terrorism," chap. 12 in *Spiritual Aspects of Clinical Work*. See also Luigi Zola, *Violence in History, Culture, and the Psyche*, trans. John Peck and Victor-Pierre Stirnimann, p. 4.

15. Jung, *The Red Book*, pp. 243, 253 and n220, 287, 288.

16. Ibid., p. 334.

17. Ibid., pp. 238n91, 253, 270, 314 and n271, 365.

18. Ibid., p. 298n189, painting 107.

19. Ibid., pp. 244, 295, 296.

20. Ibid., pp. 201, 333n6; see also Jung, *Memories, Dreams, Reflections*, pp. 170, 173, 176, 178, 189.

21. Jung, *The Red Book*, p. 295.

22. Ibid., pp. 238, 298.

23. Ibid., p. 253.

24. Ibid., p. 264.

25. Ibid., pp. 246, 300n204, 325.

26. Ibid., p. 366.

27. Ibid., p. 300.

28. Ibid., pp. 288, 300 and n204.

Chapter 2. Collective Madness

1. C. G. Jung, *The Red Book, Liber Novus*, ed. Sonu Shamdasani, trans. Mark Kyburz, John Peck, and Sonu Shamdasani, p. 238; see also George E. Atwood, *The Abyss of Madness*, p. 41.

2. Jung, *The Red Book*, p. 270.

3. Ibid., p. 352.

4. Ibid, pp. 254, 289n97. See also Ann Belford Ulanov, "The Red Book and Our Unlived Life, Both Here and Beyond," Founders Day Presentation, Jung Institute of Chicago and Loyola University Chicago, March 2011 (available on tape).

5. Police Chief Daryl Roberts interview by John Dankosky, "Big City Violence," *Where We Live*, National Public Radio, Woodbury, Conn., July 14, 2011.

6. Director Steven James interview by Terry Gross, *Fresh Air*, National Public Radio, Woodbury, Conn., August 1, 2011. Another striking example of making space is the work of Leymah Roberts Gbowee, executive director of the Women's Peace and Security Network Africa, based in Accra, Ghana. As founding member of Women in Peace Building, she organized collaborative efforts from nine of Liberia's fifteen counties. Groups of women gathered their strengths and numbers to end pernicious war by dressing in white, praying, and establishing a sex fast, withdrawing conjugal relations with their husbands, until peace was sought and established. When one meeting of men threatened to break up without results in peace building, the women surrounded the meeting place, preventing the men's exit until they worked further and reached agreement. Leymah Gbowee was later awarded the Nobel Peace Prize.

7. Anthony Lane, "Hack Work: A Tabloid Culture Runs Amok," *The New Yorker*, Aug. 1, 2011, p. 25; Jung, *The Red Book*, pp. 300, 333, 339, 359. I must note another boon from closer connections between cultures through the Internet. We can better discern the underlying image from which a culture grows and, surprisingly, see some of that other image appearing in our own culture. I was struck by Astrid Berg's noting that Africa does not labor under the Cartesian body-mind split duality that Western Europe and America do. We must labor to reach the unity beneath and beyond the either/or of binary thinking. Berg says that although "there is no single Africcan philosophy and culture . . . there are common underlying motifs." Berg sees the South African notion of Ubuntu—the spirit of of concern for and recognition of each other, of meaning "a person is a person because of persons," "I am because we are"—as such a motif. This motif is illustrated by the idea, which Margaret Lawrence shares, that we are all parents to all children, responsible for sheltering and fostering their creativity, that we are one community. Berg, a white psychiatrist-psychoanalyst in Capetown, South Africa, and Lawrence, a black psychiatrist-psychoanalyst in Harlem, New York City, share this same view. (See Astrid Berg, "Ubuntu: A Contribution to the 'Civilization of the Universal,'" chap. 16 in *The Cultural Complex: Contemporary Jungian Perspectives on Psyche and Society*, ed. Thomas Singer and Samuel L. Kimbles, pp. 244–45).

8. Ann Belford Ulanov, *The Unshuttered Heart: Opening to Aliveness and Deadness in the Self*, pp. 196–99; see also Ann Belford Ulanov, "When Religion Prompts Terrorism," in *Spiritual Aspects of Clinical Work*, pp. 313–20.

9. C. G. Jung, "The Tavistock Lectures," in *The Symbolic Life*, vol. 18 of *Collected Works*, para. 231.

10. Melanie Starr Costello, *Imagination, Illness, and Injury: Jungian Psychology and the Somatic Dimensions of Perception*, chap. 1; see also Ann Belford Ulanov, "Transference, the Transcendent Function, and Transcendence," in *Spiritual Aspects of Clinical Work*, p. 324.

11. C. G. Jung, *Two Essays in Analytical Psychology*, vol. 7 of *Collected Works*, para. 111.

12. Jung, *The Red Book*, pp. 231, 246, 247n164, 249, 301.

13. C. G. Jung, "The Development of the Personality," in *The Development of the Personality*, vol. 17 of *Collected Works*, para. 319. See also Ann Belford Ulanov, "Losing, Finding, and Being Found" *Quadrant* 37, no. 2 (Summer 2007): 55–56.

14. Jung, "The Development of the Personality," para. 319.

15. C. G. Jung, *Mysterium Coniunctionis*, vol. 14 of *Collected Works*, paras. 593, 605; and below, chapter 3, p. 66 and chapter 4, p.74.

16. C. G. Jung, *Letters*, vol. 2, ed. Gerhard Adler and Aniele Jaffé, trans. R. F. C. Hull, 24 November 1953, p. 135. See also Ann Belford Ulanov, "Spiritual Aspects of Clinical Work," in *The Functioning Transcendent: A Study in Analytical Psychology*, pp. 12–16.

17. Jung, *The Red Book*, pp. 240, 243, 314n271, 366.

18. Ibid., pp. 290, 291n150. New Yorkers remember the crime against Kitty Genovese, a young woman attacked at night coming out of the subway and pursued down the street. She screamed again and again for help. People heard, but no one ran to help. No one called the police in time to save her life. When this was reported in the press, many of us dreaded that we, too, might have succumbed to such passivity.

19. A frequent misunderstanding assumes that feeling types do not think well, are subject to inferior thinking. In fact, their thinking just differs from that of thinking types. Thinking for the feeling types, when developed, tends to emerge from very deep roots in their psyches, differentiating the fundamental value of a point of view or a question and issuing in profound and original thoughts.

20. Jung, *The Red Book*, p. 291.

21. Ibid.; Murray Stein, "Critical Notice: *The Red Book*," *Journal of Analytical Psychology* 53, no. 5 (2010): 426–27.

22. Jung, *The Red Book*, p. 291.

23. Ibid.

24. Ibid.

25. Ibid., p. 301.

26. Ibid., pp. 319, 320, 322, 323.

27. Ibid., pp. 320, 321. See also Alice Howell, *The Dove in the Stone: Finding the Sacred in the Commonplace*, pp. 23–25; Ami Ronnberg and Kathleen Martin, eds., *The Book of Symbols: Reflections on Archetypal Images*, pp. 104–7; *The Revelation of St. John the Divine* 2:17: I "will give him a white stone."

28. Jung, *The Red Book*, p. 301.

Chapter 3. The Compelling Complex

1. In the fashions of psychoanalysis, the new emphasis of Relational Analysis is on what Relationists call "self-states"—what Jung called our complexes. The Relationists question the notion of a unitary self, preferring the idea that we are made up of numerous self-states that need to talk to one another. Jung had this idea about complexes and indeed locates madness in a complex overcoming us so we are in it instead of it being in us, though Jung sees our self as both multiple and one. He sees the psyche as dissociating more than repressing. The complexes, or self-states, can break apart from one another, segregate some into neighborhoods not to be entered, and give others a lot of energy and development and defend them closely. From this picture we can see the interpenetrating of what is inside us with what is outside us in actual neighborhoods and actual defended privileges denied to others. See Philip M. Bromberg, *Standing in the Spaces: Essays on Clinical Process, Trauma, and Dissociation*, chap. 17; C. G. Jung, "A Review of Complex Theory," *The Structure and Dynamics of the Psyche*, vol. 8 of *Collected Works*; Ann Belford Ulanov, "The Many in the One and the One in the Many" in *Montreal 2010: Facing Multiplicity: Psyche, Nature, Culture*, Proceedings of the XVIIIth Congress of the International Association for Analytical Psychology, CD-ROM, pp. 214–27.

2. W. R. Bion, *Attention and Interpretation*.

3. C. G. Jung, *The Red Book, Liber Novus*, ed. Sonu Shamdasani, trans. Mark Kyburz, John Peck, and Sonu Shamdasani, pp. 235, 236, 259, 325, 326.

4. Ibid., pp. 239n97, 254 and n229, 308, 323, 347 and n85. See also C. G. Jung, *The Symbolic Life*, vol. 18 of *Collected Works*, paras. 369, 374.

5. Jung, "Review of Complex Theory," paras. 196, 197; see also C. G. Jung, "The Analysis of Dreams," *Freud and Psychoanalysis*, vol. 4 of *Collected Works*, para. 67.

6. Masud H. Khan, *The Privacy of the Self*, chap. 7, p. 98. Khan says the analyst must recognize the patient's practice of self-cure and its value and not reduce it to resistance. In fact, he continues, very few illnesses are hard to cure; what is hard to cure the patient of is his self-cure.

7. C. G. Jung, "The Tavistock Lectures," in *The Symbolic Life*, paras. 1155–56.

8. V. Volkan, "From Earthquake to Ethnic Cleansing: Messianic Trauma at the Hands of Enemies and Its Societal and Political Consequences," presentation to the Association for Psychoanalytic Medicine, New York, January 5, 2010. See also Eli Weistub and Esti-Galili Weistub, "Collective Trauma and Cultural Complexes," p. 165, and J. Gerson, "Malinchismo: Betraying One's Own," p. 41, both in *The Cultural Complex*, eds. Thomas Singer and Samuel L. Kimbles.

9. Jung, *The Red Book*, pp. 241, 253; see also pp. 341, 343.

10. Jung, "Review of Complex Theory," para. 210; Jung, *The Red Book*, p. 246; C. G. Jung, *The Symbols of Transformation*, vol. 5 of *Collected Works*, paras. 457, 458.

11. Jung, *Symbols of Transformation*, paras. 449, 460.

12. Jung, "Review of Complex Theory," para. 216; Jung, *The Red Book*, pp. 237, 241.

13. Jung, *The Red Book*, pp. 235, 359; Avivah Gottlieb Zornberg, *Genesis: The Beginning of Desire*, p. 376, citing Maharal, *Gur Arye*.

14. Zornberg, *Genesis*, p. 296.

15. For discussion of loss of subjectivity and loss of objectivity as two forms of madness, see Ann Belford Ulanov, *The Unshuttered Heart: Opening to Aliveness and Deadness in the Self*, chaps. 1 and 2.

16. Jung, *The Red Book*, pp. 246, 295 and n178 324, 365–66.

17. I am indebted to Annie Boland, MD (personal communication), for bringing this idea freshly to mind again.

18. Jung, *The Red Book*, p. 249; see also p. 308.

19. Mark Rothko, *The Late Series*, ed. Achim Borchadt-Hume, p. 91.

20. Jung, "Review of Complex Theory," para. 213.

21. Jung, *The Red Book*, pp. 300 and n204; 321.

22. Ibid., pp. 320–21.

23. Ibid., p. 321. A comment is pertinent here relevant to contemporary research of the brain. Jung is "hearing" from the Cabiri, so to speak, that psyche and its reality are not equated with the physical brain and its reality. Both are valid and they are interconnected, even mutually dependent, but they are not the same. For example, recent brain research can inform us where in the brain we dream, its site. But that does not tell us what a dream means.

24. Jung, *Symbols of Transformation*, para. 449.

25. Jung, *The Red Book*, p. 339.

26. Jung, *Symbols of Transformation*, para. 460.

27. Wallace Stevens, *The Collected Poems of Wallace Stevens*, p. 203, cited by David M. LaGuardia, *Advance on Chaos: The Sanctifying Imagination of Wallace Stevens*, p. 12.

28. Jung, *The Red Book*, p. 229.

29. C. G. Jung, *Mysterium Coniunctionis*, vol. 14 of *Collected Works*, paras. 42, 45, 49, 50.

30. C. G. Jung, *Memories, Dreams, Reflections*, rec. and ed. Aniela Jaffé, trans. Richard Winston and Clara Winston, pp. 170, 172, 173.

31. Jung, *The Red Book*, pp. 320, 368.

32. Ann Belford Ulanov and Barry Ulanov, *Religion and the Unconscious*, chap. 11; see also Ann Belford Ulanov, "Countertransference and the Self," in *Spiritual Aspects of Clinical Work*, pp. 384–89.

33. Jung, *Mysterium Coniunctionis*, paras. 128, 153.

34. Analogy can be made to the current crises around the earth, running out of energy, shortages of water and clean air. These problems can be seen as communications from our environment about its right for its own life, not just to be co-opted to our aims and greeds, annexed to our conscious exploitation. Another kind of relation of human and nonhuman is hinted at in this crisis, an interpenetrating of both/and to create a wholeness with space for both.

35. Ann Belford Ulanov, *The Female Ancestors of Christ*, pp. 5ff.

36. Anna Akhmatova, *The Complete Poems of Anna Akhmatova*, trans. Judith Hemschemmeyer, p. 384.

37. Anton Ehrenzweig, *The Hidden Order of Art*, pp. 205, 212; Jung, *The Red Book*, p. 234.

Chapter 4. From Compelling Complex to Creative Return

1. See Ann Belford Ulanov, *Finding Space: Winnicott, God, and Psychic Reality*, pp. 13ff., 125, 133, 146.

2. The acid from vomiting attacks the teeth, which often must be extracted.

3. Alice O. Howell, *The Dove in the Stone: Finding the Sacred in the Commonplace*, p. 25.

4. See, for example, Ann Belford Ulanov, "Vicissitudes of Living in the Self," chap. 10 in *The Functioning Transcendent: A Study in Analytical Psychology*, pp. 197–216.

5. A moving example of this is Sue Grand's account of allegiance to the Good Breast model of being a therapist and finding instead she disliked her patient. Sue Grand, *The Hero in the Mirror: From Fear to Fortitude*, pp. 120ff.; see also Ann Belford Ulanov, "Hate in the Analyst," chap. 16 in *Spiritual Aspects of Clinical Work*, pp. 433ff.

6. C. G. Jung, *Psychological Types*, vol. 6 of *Collected Works*, paras. 442–43. See also C. G. Jung, *The Red Book, Liber Novus*, ed. Sonu Shamdasani, trans. Mark Kyburz, John Peck, and Sonu Shamdasani, p. 231n3, and Melanie Starr Costello, *Imagination, Illness, and Injury: Jungian Psychology and the Somatic Dimensions of Perception*, pp. 67, 71.

7. Maurice Merleau-Ponty, "An Unpublished Text by Maurice Merleau-Ponty: A Prospectus of His Work," in *The Primacy of Perception*, ed. James J. Edie, trans. Arleen B. Dallery, pp. 3, 6, 18.

8. Primary process thinking is Freud's term for mental processes that reign over the instinctual id. It is subject to the pleasure principle, and these processes admit of no distinction between inner and outer, subject and object, self or other. Instinct-backed impulses abound and press for instant gratification. Mechanisms of condensation and displacement are prominent. Such mentation characterizes the unconscious, dreams, children's mental processes, and those of psychopathology. Jung's term, nondirected thinking, is similar to Freud's primary process, but Jung emphasizes that this mentation expresses our inner reality through instincts, images, and affects and is found in addition to the above list as well in myths, religions, fantasies, fairy tales, creativity, and the arts. This mentation is not pathological but is seen as the natural given life of the psyche from which directed thinking, characterizing consciousness, develops. It turns pathological only when it

dominates a person's mental functioning, overwhelming consciousness. See Neville Symington and Joan Symington, *The Clinical Thinking of Wilfred Bion*, p. 92: "This is a particular fact that suddenly occurs to the analyst which makes sense of the disparate elements previously noted. What before may have been a jumble of fragmented material now becomes unexpectedly coherent and understandable; meaning suddenly dawns."

9. Jung, *The Red Book*, pp. 234 and n58, 301n211, 368, and painting, p. 113. See also Richard Kearny, *Anatheism: Returning to God after God*, p. 8: "beyond accredited concepts and conventions."

10. C. G. Jung, "Psychology of the Transference" in *The Practice and Theory of Psychotherapy*, vol. 16 of *Collected Works*, para. 419: incest "symbolizes union with one's own being . . . individuation or becoming a self." See also Jung, *The Red Book*, p. 368.

11. C. G. Jung, *Memories, Dreams, Reflections*, rec. and ed. Aniela Jaffé, trans. Richard Winston and Clara Winston, pp. 176–77; Anton Ehrenzweig, *The Hidden Order of Art: A Study in the Psychology of Artistic Imagination*, pp. 205, 212; D. W. Winnicott, "The Capacity to Be Alone," in *The Maturational Processes and the Facilitating Environment*, p. 34; C. G. Jung, *Psychology and Alchemy*, vol. 12 of *Collected Works*.

12. Jung, *The Red Book*, p. 243; Jung, *Psychological Types*, paras. 196, 197; Marion Milner, "The Ordering of Chaos," in *The Suppressed Madness of Sane Men: Forty-Four Years of Exploring Psychoanalysis*, pp. 227–28; Wallace Stevens, *The Collected Poems of Wallace Stevens*, p. 406, cited in David M. La Guardia, *Advance on Chaos: The Sanctifying Imagination of Wallace Stevens*, pp. 68, 75, 79.

13. Jung, *The Red Book*, p. 234.

14. Claudia Roth Pierpont, "Black, Brown, and Beige: Duke Ellington's Music and Race in America," *The New Yorker*, May 17, 2010, pp. 99ff.

15. Ann Belford Ulanov, "Ritual, Repetition, and Psychic Reality," chap. 15 in *Spiritual Aspects of Clinical Work*, pp. 401ff.; Jung, *The Red Book*, p. 230.

16. Ann Belford Ulanov, "The Perverse and the Transcendent," chap. 3 in *The Functioning Transcendent: A Study in Analytical Psychology*.

17. Ann Belford Ulanov and Barry Ulanov, "Moral Masochism and Religious Submission," chap. 10 in *Religion and the Unconscious*. For case examples, see Ann Belford Ulanov, "Transference, the Transcendent Function, and the Transcendent," and "Countertransference and the

Self," chaps. 13 and 14, respectively, in *Spiritual Aspects of Clinical Work*, pp. 337–50, 371–84.

18. Jung, *The Red Book*, pp. 300, 320.

19. For example, Marguerite Porete, *The Mirror of Simple Souls*, trans. Ellen L. Babinsky: "the stage of freeness," chaps. 41–48, and "the peace of divine life," chaps. 66, 82, 85, 93.

20. Jung, *The Red Book*, p. 247.

21. For a very funny example of such coincidence, see Ladson Hinton, "The Enigmatic Signifier and the Decentered Subject," *Journal of Analytical Psychology* 54, no. 5 (2009): 647, 648. After much analytical work, Hinton describes a critical turning point that led to a new path in his analysand: "a timeless moment between us, and a capacity to experience his core enigma as creative rather than merely as a terrifying and destructive gap. . . . One day he came into the room and lapsed into a pained silence that felt very different than the silence of the 'gaps.' Then he suddenly gave me a piercing, angry look and burst out, 'What in the hell are we doing here?!' With little hesitation the words sprang from my lips, 'Fuck if I know!' I was totally startled by my own words, as was he. It was very tense for a moment, and time seemed strangely suspended. After this pause in some atemporal-seeming space, he flushed and I flushed, and we broke down in mutual peals of deep belly laughter." Later Hinton says, "Our enigmas touched, opening a space for renewed life in our relationship, and a new spaciousness in his being as a subject . . . a shift or partial re-creation of his subjectivity."

22. Jung, *The Red Book*, p. 235.

23. Ann Belford Ulanov, "What If You Cannot Forgive? If Forgiveness Does Not Happen?" paper delivered to Assisi Institute, Assisi, Italy, 2009, and to Dayton, Ohio, Jung Society, 2009; Jung, *The Red Book*, p. 354 and n123.

24. Jung, *The Red Book*, pp. 231, 245, 252n211, 260, 265, 367.

25. John Beebe, "John Beebe in Conversation with Beverley Zabriskie," *Journal of Analytical Psychology* 56, no. 3 (June 2011): 421.

26. Jung, *The Red Book*, p. 330.

27. Jung, *Memories, Dreams, Reflections*, p. 192.

28. Jung, *The Red Book*, pp. 231, 233, 249, 308.

29. Ibid., p. 299.

30. Ann Belford Ulanov, "Fatness and the Female," chap. 2 in *The Functioning Transcendent*.

31. See Jean-Luc Marion, *God Without Being*, trans. Thomas A. Carlson, pp. 7–16.

32. C. G. Jung, *Letters*, vol. 1, 1906–1950, ed. Gerhard Adler and Aniele Jaffé, trans. R. F. C. Hull, 26 May 1923, p. 41; C. G. Jung, "Commentary on 'The Secret of the Golden Flower,'" in *Alchemical Studies*, vol. 13 of *Collected Works*, para. 55. See also Jung, The Red Book, p. 267n44.

33. Ann Belford Ulanov, "The Third in the Shadow of the Fourth," *Journal of Analytical Psychology* 52, no. 5 (2007): 591–92; Ulanov, "Repetition, Ritual, and Psychic Reality," pp. 393–95.

34. Susan Rowland, "Ghost and Self: Jung's Paradigm Shift and a Response to Zinkin," *Journal of Analytical Psychology* 54, no. 5 (2009)): 698.

35. D. W. Winnicott, *The Maturational Processes and the Facilitating Environment.*

36. W. R. Bion, *Transformations*, p. 159.

37. Jung, *The Red Book*, pp. 337, 338, 339.

38. Ibid., pp. 324, 330, 337, 338, 339, 345.

39. Ibid., pp. 347–48, 354n123, 370.

40. Ibid., p. 356.

41. Ulanov, "Repetition, Ritual, and Psychic Reality," pp. 371, 376, 380, 413–15; Mark Saban, "Entertaining Strangers," *Journal of Analytical Psychology* 56, no. 1 (2011): 102; Richard Kearney, "Epiphanies of the Everyday: Toward a Micro-Eschatology," chap. 1 in *After God: Richard Kearney and the Religious Turn in Continental Philosophy*, ed. John Panteleimon Manoussakis; Jo-Ann Culbert Koehn, "An Analysis with Bion: An Interview with James Gooch," *Journal of Analytical Psychology* (56, no. 1, (2011): 76–92), pp. 81–82. Kearney sums up four "reductions" that open this space. The first "transcendental reduction" of Husserl "brackets our natural attitude of habit and opinion to return to the 'essences' of meaning . . . to the invariant essential structures underlying them [that] would lead us . . . to an inner realm of transcendental consciousness" (p. 5). The second "ontological reduction" of Heidegger is "from the essences of beings to being as being" (p. 5). The third "donological reduction" is Jean-Luc Marion's "return to the gift" and to "'saturated phenomenon' . . . to the giveness of the gift" (pp. 5–6). Kearney adds a fourth "reduction": "back to the everyday . . . of simple, embodied life where we may confront the other 'face-to-face'" (p. 6). "We discover ourselves *before* God in a new way, recovering, by way of creative repetition, what was always there in the first place, but remained unseen" (p. 7).

Bibliography

Akhmatova, Anna. *The Complete Poems of Anna Akhmatova.* Translated by Judith Hemschemeyer. Boston: Zephyr Press, 1993.

Atwood, George Eliot. *The Abyss of Madness.* New York: Routledge, 2012.

Austin, Sue. "Jung's Dissociable Psyche and the Ec-static Self. *Journal of Analytical Psychology* 54, no. 5 (November 2009): 581–601.

Balint, Michael. *The Basic Fault: Therapeutic Aspects of Regression.* London: Tavistock, 1968.

Beebe, John. "John Beebe in Conversation with Beverley Zabriskie." *Journal of Analytical Psychology* 56, no. 3 (June 2011): 407–24.

Berg, Astrid. "Ubuntu: A Contribution to the 'Civilization of the Universal.'" In *The Cultural Complex: Contemporary Jungian Perspectives on Psyche and Society*, edited by Thomas Singer and Samuel L. Kimbles, 239–51. New York: Routledge, 2004.

Bion, W. R. *Attention and Interpretation.* London: Tavistock, 1970.

———. *Transformations.* London: Karnac, 1965.

Brennan, Eric. "The Recovery of the Good Object Relationship: The Conflict with the Superego." In *The Recovery of the Lost Good Object.* Edited by Giglioa Fornari Spoto, 94–107. New York: Routledge, 2006.

Bromberg, Philip M. *Standing in the Spaces: Essays on Clinical Process, Trauma, and Dissociation.* Hillsdale, NJ: Analytic Press, 1998.

Costello, Melanie Starr. *Imagination, Illness, and Injury: Jungian Psychology and the Somatic Dimensions of Perception.* New York: Routledge: 2006.

Culbert Koehn, Jo-Ann. "An Analysis with Bion: An Interview with James Gooch." *Journal of Analytical Psychology* 56, no. 3 (2011): 76–92.

Ehrenzweig, Anton. *The Hidden Order of Art: A Study in the Psychology of Artistic Imagination.* Berkeley: University of California Press, 1967.

Gerson, Jacqueline. "Malinchismo: Betraying One's Own," in *The Cultural Complex.* Edited by Thomas Singer and Samuel L. Kimbles, pp. 35–46. New York: Routledge, 2004.

Grand, Sue. *The Hero in the Mirror: From Fear to Fortitude.* New York: Routledge, 2010.

Hinton, Ladson. "The Enigmatic Signifier and the Decentered Subject." *Journal of Analytical Psychology* 54, no. 5 (November 2009): 637–59.

Howell, Alice. *The Dove in the Stone: Finding the Sacred in the Commonplace.* Weaton, IL: Quest Books, 1996.

Jung, Carl Gustav. "The Analysis of Dreams." In *Freud and Psychoanalysis*, vol. 4 of *Collected Works*. New York: Pantheon, 1909; reprint, Princeton, NJ: Princeton University Press, 1961.

———. "Commentary on 'The Secret of the Golden Flower.'" In *Alchemical Studies*, vol. 13 of *Collected Works*. New York: Pantheon, 1957; reprint, Princeton, NJ: Princeton University Press, 1967.

———. "The Development of the Personality." In *The Development of Personality*, vol. 17 of *Collected Works*. New York: Pantheon, 1935; reprint Princeton, NJ: Princeton University Press, 1954.

———. *Letters*, vol. 1, 1906–1950. Edited by Gerhard Adler and Aniela Jaffé; translated by R. F. C. Hull. Princeton, NJ: Princeton University Press, 1973.

———. *Letters*, vol. 2, 1951–1961. Edited by Gerhard Adler and Aniela Jaffé; translated by R. F. C. Hull. Princeton, NJ: Princeton University Press, 1975.

———. *Memories, Dreams, Reflections*. Recorded and edited by Aniela Jaffé; translated by Richard Winston and Clara Winston. New York: Pantheon, 1963.

———. *Modern Man in Search of a Soul*. Translated by Cary F. Baynes and D. S. Dell. New York: Harcourt, Brace and Co., 1933.

———. *Mysterium Coniunctionis*, vol. 14 of *Collected Works*. Princeton, NJ: Princeton University Press, 1963.

———. *Psychological Types*, vol. 6 of *Collected Works*. Princeton, NJ: Princeton University Press, 1971.

———. "Psychology of the Transference." In *The Practice of Psychotherapy: Essays on the Psychology of the Transference and Other Subjects*, vol. 16 of *Collected Works*. New York: Pantheon, 1946; reprint, Princeton, NJ: Princeton University Press, 1954.

———. *The Red Book, Liber Novus*. Edited by Sonu Shamdasani; translated by Mark Kyburz, John Peck, and Sonu Shamdasani. New York: W. W. Norton, 2009.

———. "A Review of Complex Theory." In *The Structure and Dynamics of the Psyche*, vol. 8 of *Collected Works*. New York: Pantheon, 1948; reprint Princeton, NJ: Princeton University Press, 1960.

———. *The Symbols of Transformation*, vol. 5 of *Collected Works*. Princeton, NJ: Princeton University Press, 1956.

————"The Tavistock Lectures." *The Symbolic Life*, vol. 18 of *Collected Works*. Princeton, NJ: Princeton University Press, 1976.

————. *Two Essays in Analytical Psychology*, vol. 7 of *Collected Works*. New York: Pantheon, 1953; reprint Princeton, NJ: Princeton University Press, 1966.

Kearney, Richard. *Anatheism: Returning to God after God*. New York: Columbia University Press, 2011.

————. "Epiphanies of the Everyday: Toward a Micro-Eschatology." In *After God: Richard Kearney and the Religious Turn in Continental Philosophy*. Edited by John Panteleimon Manoussakis. New York: Fordham University Press, 2006.

Khan, Masud R. *The Privacy of the Self*. New York: International Universities Press, 1974.

LaGuardia, David M. *Advance on Chaos: The Sanctifying Imagination of Wallace Stevens*. Hanover and London: University Press of New England for Brown University, 1983.

Lane, Anthony. "Hack Work: A Tabloid Culture Runs Amok." *The New Yorker*, August 1, 2011, pp. 24–30.

Marion, Jean-Luc. *God Without Being*. Translated by Thomas A. Carlson. Chicago: Chicago University Press, 1995.

Merleau-Ponty, Maurice. "An Unpublished Text by Maurice Merleau-Ponty: A Prospectus of His Work." In *The Primacy of Perception*. Edited by James J. Edie; translated by Arleen B. Dallery, pp. 3–12. Evanston, IL: Northwestern University Press, 1964.

Milner, Marion. "The Ordering of Chaos." In *The Suppressed Madness of Sane Men: Forty-Four Years of Exploring Psychoanalysis*, 216–34. London and New York: Tavistock 1957; reprint, New York: Routledge, 1987.

Ogden, Thomas H. *Reverie and Interpretation: Sensing Something Human*. London: Karnac, 1999.

Pierpont, Claudia Roth. "Black, Brown, and Beige: Duke Ellington's Music and Race in America." *The New Yorker*, May 17, 2010, 96–103.

Porete, Marguerite, *The Mirror of Simple Souls*. Translated by Ellen L. Babinsky. Mahwah, NJ: Paulist Press, 1993.

Ronnenberg, Ami, and Kathleen Martin, eds. *The Book of Symbols: Reflections on Archetypal Images*. New York: Taschen, 2010.

Rothko, Mark. *The Late Series*. Edited by Achim Borchadt-Hume. London: Tate, 2005.

Rowland, Susan. "Ghost and Self: Jung's Paradigm Shift and a Response to Zinkin." *Journal of Analytical Psychology* 54, no. 5 (November 2009): 697–717.

Schwartz-Salant, Nathan. *The Black Nightgown: The Fusional Complex and the Unlived Life.* Wilmette, IL: Chiron, 2007.

Stein, Murray. "Critical Notice: *The Red Book.*" *Journal of Analytical Psychology,* 53, no. 5 (2010): 428–34.

Stevens, Wallace. *The Collected Poems of Wallace Stevens.* New York: Alfred A. Knopf, 1954.

Symington, Neville, and Joan Symington. *The Clinical Thinking of Wilfred Bion.* New York: Routledge, 1996.

Ulanov, Ann Belford. *Attacked by Poison Ivy: A Psychological Understanding.* York Beach, Maine: Nicolas-Hays, 2001.

———. "Countertransference and the Self." In *Spiritual Aspects of Clinical Work,* 353–92. Einsiedeln, Switz.: Daimon, 1999, reprint 2004.

———. "Fatness and the Female." In *The Functioning Transcendent: A Study in Analytical Psychology,* 33–52. Wilmette, IL: 1996.

———. *The Female Ancestors of Christ.* Einsiedeln, Switz.: Daimon, 1993; reprint, 1998.

———. *Finding Space: Winnicott, God, and Psychic Reality.* Louisville, KY: John Knox and Westminster Press, 2001.

———. "Hate in the Analyst." In *Spiritual Aspects of Clinical Work,* 425–55. Einsiedeln, Switz.: Daimon, 2001; reprint, 2004.

———. "The Holding Self: Jung and the Desire for Being." In *Spirit in Jung,* 75–100. Einsiedeln, Switz.: Daimon, 1992; reprint, 2005.

———. "Losing, Finding, and Being Found." *Quadrant* 37, no. 2 (Summer 2007): 45–63.

———. "The One in the Many and the Many in the One." In *Montreal 2010: Facing Multiplicity: Psyche, Nature, Culture.* Proceedings of the XVIIIth Congress of the International Association for Analytical Psychology, pp. 214–27. Einsiedeln, Switz.: Daimon, 2011, CD-ROM.

———. "The Perverse and the Transcendent." In *The Functioning Transcendent: A Study in Analytical Psychology,* 52–71. Wilmette, IL: 1996.

———. "The Red Book and Our Unlived Life, Both Here and Beyond." Founders Day Presentation, Jung Institute of Chicago and Loyola University Chicago, March 2011 (available on tape).

———. "Ritual, Repetition, and Psychic Reality." In *Spiritual Aspects of Clinical Work*, 392–425. Einsiedeln, Switz.: Daimon, 1996; reprint, 2004.

———. "Spiritual Aspects of Clinical Work." In *The Functioning Transcendent: A Study in Analytical Psychology*, 3–33. Wilmette, IL: Chiron, 1996.

———. "The Third in the Shadow of the Fourth." *Journal of Analytical Psychology* 52, no. 5 (2007): 585–607.

———. "Transference, the Transcendent Function, and Transcendence." In *Spiritual Aspects of Clinical Work*, 321–52. Einsiedeln, Switz.: Daimon, 1997; reprint, 2004.

———. *The Unshuttered Heart: Opening to Aliveness and Deadness in the Self.* Nashville, Tenn.: Abingdon, 2007.

———. "Vicissitudes of Living in the Self." In *The Functioning Transcendent: A Study in Analytical Psychology*, 197–216. Wilmette, IL: Chiron, 1996.

———. "What If You Cannot Forgive? If Forgiveness Does Not Happen?" Assisi, Italy: Assisi Institute, 2009.

———. "When Religion Prompts Terrorism." In *Spiritual Aspects of Clinical Work*, 313–21. Einsiedeln, Switz.: Daimon, 2001; reprint, 2004.

———, and Barry Ulanov. *Religion and the Unconscious.* Louisville, KY: John Knox and Westminster Press, 1975.

Volkan, V. "From Earthquake to Ethnic Cleansing: Messianic Trauma at the Hands of Enemies and Its Societal and Political Consequences." Presentation to the Association for Psychoanalytic Medicine, New York, January 5, 2010.

Weistub, Eli, and Esti-Galili Weistub. "Collective Trauma and Cultural Complexes." In *The Cultural Complex*. Edited by Thomas Singer and Samuel L. Kimbles, 147–71. New York: Routledge, 2004.

Winnicott, D. W. "The Capacity to Be Alone." In *The Maturational Processes and the Facilitating Ego*, 29–37. New York: International Universities Press, 1965.

———. "Ego Distortion in Terms of True and False Self." In *The Maturational Processes and the Facilitating Environment*, 140–53. New York: International Universities Press, 1965.

———. *Playing and Reality.* New York: Basic Books, 1971.

Zola, Luigi. *Violence in History, Culture, and the Psyche.* Translated by John Peck and Victor-Pierre Stirnimann. New Orleans, LA: Spring Books, 2009.

Zornberg, Avivah Gottlieb. *Genesis: The Beginning of Desire.* Philadelphia and Jerusalem: The Jewish Publication Society, 5755/1995.

Index

Akhmatova, Anna, 68; *The Requiem*, 68

analysis, 69, 90; and madness, 10; as ritual, 79; and subjectivity, 13, 43

annihilation, 59, 61, 76, 79; and new life, 49, 63, 78

anthropos (image of the whole), 31, 66, 74. *See also* archetype: of wholeness

archetypes, 55, 72, 74; archetypal image, 53–55, 71, 85; the shadow, 31, 66, 72; of wholeness, 4, 31, 49, 56, 64, 74, 102n34. *See also* self (the)

atonement, 33–34, 63.*See also* evil: sacrifice

Augustine, Saint, 93

Battle of Kosovo, 46

Beers, Clifford, ix

being/nonbeing, x, 7, 9–11, 59, 64, 104n10; and Heidegger, x, 106n41

Berg, Astrid, 98n7

Bernard of Clairveaux, 88

Bion, Wilfred, 42, 88, 90

Boland, Annie, 101n17

Cezanne, Paul, 75, 78

chaos, 13, 22, 55, 71; and acceptance, 16, 17, 19, 38, 82; beyond chaos, 72, 76, 78; as the other half of life, 2, 8, 16, 33, 50, 69–70, 82; Jung's chaos, 2, 17, 33, 58

collective madness (*examples*): Columbine, 27; corruption, 27, 50, 93; economic recession (global), 24–25; Japan's natural disasters, 23; loss of community identity, 25–26; Oslo, Norway, massacre, 22; political gridlock, 25; technological impact, 25–26 (*see also* Facebook; Internet); and terrorist attacks, 27; the U.S. gulf oil spill, 23–24; Virginia Tech, 27

complexes, 10, 29, 44–46, 48–49; as ancestor, 3, 41, 42, 46, 49, 63, 68; and avoidance (of our own way), 36, 52, 83; captives of, 3, 44, 53–55, 61, 67, 79; the compelling complex, 4, 44–46, 55 (*see also* annihilation); cultural (communal), 31, 46, 51, 68; ego complex, 45 (*see also* ego); inferiority complex, 13, 18–19, 33, 41, 49, 99n19; inside/outside the psyche, 18, 26, 49, 64, 81, 100n1; oedipal complex, 48; persecution complex, 49; physical signs of, 12, 45, 57, 65, 86; realignment of, 43; the repeating complex, 13, 42,

complexes (*cont.*)

47, 50, 64, 71 (*see also* repetition compulsion); and space-making (*see* space [psychic]/the gap); unconscious complex, 45 (*see also* conscious/unconscious); as "*via regia*," 48. See also *complexio oppositorum*

complexio oppositorum, 4, 73;

conscious/unconscious, 11, 103–104n8; and archetypal energy, 53–55; and child/adult consciousness, 74–76, 81–82; and collective madness, 30–32 (*see also* madness); and dreams, 71, 103n8; to expand consciousness, 42, 44, 50, 71, 73, 76 (*see also* space [psychic]/the gap); meeting of conscious and unconscious, 63–67, 80; and reality, 91, 93; and somatic maladies, 12; space-making consciousness, 66, 71, 73 (*see also* space [psychic]/the gap: and consciousness); transcendental consciousness, 106n41; and truth, 51; unconscious complex, 43, 45, 52, 91. *See also* complexes; dots of light; ego: I-ness

corruption, 27, 83. See also *Red Book, The:* and the worm (of corruption)

creativity, 1, 3, 103n8; and the coexistence of madness , 1, 3, 12, 41–42, 56, 90; and creative return, 4, 70, 72, 76, 79, 83–85, 87; and destructiveness (*see also* destructiveness); and the God-image, 3, 4, 32, 34, 35, 58, 63, 78, 87 (*see also* God: and our god-making; ruling principle); and meaninglessness, 3 (*see also* meaning/meaninglessness); psychic creativity, 76–78, 81–82, 93; and the path through madness, 70, 82, 86; and the rebirth experience, ix, x, 63, 70, 72–75, 76

darkness, x, 32, 88, 89; light in darkness, ix-x (*see also* dots of light)

dedifferentiation, 76

destructiveness, 19, 29–30, 32, 35; communal, 31; finding its place, 37, 50, 77, 79, 81–82 (*see also* evil; meaning/meaninglessness)

differentiation 73, 89, 92

Disappeared (the), 51

disorientation, 20–22, 38

dots of light (scintillae), 1, 3, 12, 19, 27–29, 81; indicators of a pathway, 59, 65–66, 70, 72, 84, 88, 90; and repetition complex, 79. *See also* healing; space (psychic)/the gap

dreams, 47, 52, 53, 69; and brain research, 102n23; role of, 45, 48, 71

Dylan, Bob, x

ego, ix–x, 4, 10, 73 (*see also* ruling principle); as captive of madness, 28, 44, 48, 52, 53; dream-ego, 45 (*see also* dreams); freedom of, 50, 67, 71 (*see also* space (psychic)/the gap; I-ness (conscious ego), 44–45, 53, 66–67, 76

Ehrenzweig, Anton, 76

Ellington, Duke, 78

evil: to acknowledge, 19, 28, 31–38, 42, 59–63; anchoring of , 3, 31–38, 42, 57, 59–63; assistance of , 34–37, 62–63; and atonement (to atone), 33, 34, 63; collective/communal, 29, 31, 61, 63, 90; and the devil, 37, 42; facing evil, x, 2–3, 19–20, 27–33, 42, 57–59, 61, 80; in the foundation of life, 3, 31, 37, 56, 57–58, 80, 90; and good, x, 30–32, 37, 38, 42, 59, 77, 82, 89, 91; and the "lowest in you" (*see* incapacity: the lowest in you/us); and sacrifice of the ruling principle (*see* sacrifice: of the ruling principle)

existentialism, 59

Facebook, 26–27

Fay Lecture Series, i, xi

Fitzgerald, F. Scott, *Tender Is the Night,* 28

Freud, Sigmund, ix, x, 47, 76; and dislodged identity, 47; Jung's severance with, 16; and primary process thinking, 103n8

gap, 50–53; becomes space 55–58. *See also* space (psychic)/the gap

Gbowee, Leymah Roberts, 98n6

Genovese, Kitty, 99n18

God, 33, 50; and animal, 49, 64; the Divine, 17; and disorientation, 20, 28, 34; and our god-making capacity, x, 4, 35–36, 60, 77–78, 81, 85–91, 92, 106n41; and our

God-image, 3, 4, 20, 34, 58, 63, 92. *See also* creativity: and the God-image; ruling principle; sacrifice; soul (the)

Grand, Sue, 13, 103n5

Gregory of Nyssa, 88

healing, ix, 9, 27–29; and the small, 80. *See also* dots of light

Heidegger, Martin, x, 106n41

Hillman, James, ix

Hinton, Ladson, 105n21

Hitler, Adolf, 48

Hodges, Johnny, 78

hope/hopelessness, x, 75, 79, 88; and madness, 1

Husserl, Edmund, 106n41

incapacity 14–15, 18–19, 60; the lowest in you/us, 19, 20, 27, 30, 34, 57, 61; and the repeating complex, 50, 64 (*see also* complexes: the repeating complex)

individuation, 54, 82, 84, 89, 104n10

I-ness. *See* ego: I-ness

International Court of Justice, 51

Internet, 26, 98n7

Interrupters of Violence (film), 26

James, William, ix

Jamison, Kay Redfield, ix

Jung, C. G., ix; and his acceptance, 90; finding his soul, 88–91; and multiplicity, 4, 16, 90; and the other half of life (world), 2, 8, 16, 33, 69, 82; and the psyche, 77; and

self, 89; and serious play, 77; and supreme meaning, 4. See also *Red Book, The:* ruling principle

Kearney, Richard, 90, 106n41
Khan, Masud H., 101n6
King, Martin Luther, Jr., 78
knowing and not knowing (unknowing), 13, 43, 65, 88, 92; madness of, 11–12, 35, 55, 59. *See also* madness

Lawrence, Margaret, 98n7
Levinas, Emmanuel, *Ethics and Infinity,* x

madness (psychosis), 1; and acceptance, 16, 19, 24, 31, 81, 83; and the breakdown, 7–10, 71; and chaos, 2, 13 (*see also* chaos); and clinical analysis, 8, 13; as collective (the human condition), 8, 20–38; of the complex, 46, 47 (*see also* complexes); cultural, 22, 51; and isolation, 9, 28; personal, 7–19; social effects of, 12–14; and subjectivity, 50, 52, 53, 75. *See also* creativity: and the coexistence of madness; meaning/meaninglessness; space (psychic)/the gap
Marion, Jean-Luc, 106n41
Marlan, Stanton, ix
Matthews, Amina, 26
meaning/meaninglessness, x, 2, 3, 9, 33, 98n7; assaults on, 24–26; and creative return, 71, 72; essences of,

106n41; finding, 12, 20–22, 81–82, 104n8 86; guiding (*see* ruling principle); myths of, 22; only "one," 16, 34, 37; supreme, 4; symbolic, 11. *See also* knowing and not knowing; order/disorder
Merleau-Ponty, Maurice, 75
Milner, Marion, 77
Milošević, Slobodan, 46, 51
Museum of Modern Art (New York), 56

Nietzsche, Friedrich Wilhelm, 59
Nobel Peace Prize, 22, 98n6
nothingness (nothing there), 9, 15, 20, 22, 50; and freedom, 26, 32, 58, 81, 90; and the other half of life, 59, 82; v. something, 55, 57, 60
numinosum, 50

object relations theory, 43
order/disorder, 2, 4, 8, 11, 15, 50; communal (order/disorder), 25; and disorientation, 21; as madness, 13, 19, 52; and meaning, 34–35, 70; as a threat, 17. *See also* space (psychic)/the gap

Pentecost: and Tower of Babel, 91
perception: and madness, 10, 41; and recognition of others, 75; and unconscious identification with archetypal energy, 53–54
Picasso, Pablo, 56
Presley, Elvis, 85
psyche: as the *anthropos,* 31, 66 (see

also *anthropos);* and creativity, 76–78, 88 (*see also* rebirth experience); and directed thinking, 103n8; and dissociation, 100n1; and the ego, 10, 28, 44; point(s) of view of, 2, 4, 16, 28, 45, 48, 50, 55, 91; personal/impersonal, 35, 43; as a reality, 58, 64, 74, 84, 102n23; and transcendent, 22, 27, 86, 87, 88, 106n41 (*see also* God: and our god-making capacity)

psychosis, 2, 11, 16

rebirth. *See* creativity: and rebirth experience
Red Book, The, ix–x, 2–4; Abraxas, 17, 89, 90; the Cabiri, 58–59, 65, 102n23; the divine child, 70, 74, 76, 77, 89, 90; Christ, 89, 90; Eros, 16, 33, 34, 35; Hap, 89, 90; the Holy One, 18, 33; Logos, 16, 33, 34, 35; Philemon, 24, 82, 89, 90; Salome, 18, 33, 53, 84, 88–89; Satan, 37, 58; and the worm (of corruption), 27, 50, 58, 59, 93

relational analysis, 100n1
repetition compulsion, 47–50, 73, 83, 87
Rilke, Rainer Maria, 78
ritual, 4, 78–81, 85, 87. *See also* God: and our god-making
Rothko, Mark, 56
ruling principle, ix, 14, 15, 16; and Hell, 18, 55; and incapacity, 18; losing of, 17, 20, 60, 62–63; relinquishment of, 18, 35, 61, 81

sacrifice: and atonement, 33–34, 63; and evil, 62–63; and loss, 57; of the myth of justification 47; of the ruling principle, ix, 14, 28, 32, 35, 57–58
Schiller, Friedrich, 77
Schwartz-Salant, Nathan, 13
self, (the), 59, 55–56, 73, 90, 100n.1; and God, 88, 89; self-creating of, 70, 76, 83; self-states, 100n.1; shattering of 7. *See also* complex
soul (the): as a child, 75; Jung's considerations of, 2, 4, 8, 11, 16–17, 19, 21, 88–89; the losing of, 29, 33–35; and meaninglessness, 42, 82; messages of , 57, 72
space (psychic)/the gap: and consciousness, 66–68, 70, 80; creating psychic space, 20, 44, 52, 65, 67–68, 71–73, 98n6; definitions of, 11; and differentiation, 92, 102n34; and disorientation, 20, 50; facing the gap, 4, 9–11, 26, 50–53, 55, 60, 69, 105n21; "a space of openess," 90; and synthesis, 77–78, 93; and transforming space, 69, 71–73. *See also* dots of light
Stevens, Wallace, 64, 77
Strayhorn, Billy, 78
Styron, William, ix

Tower of Babel: and Pentecost, 91
trauma: as captor, 3, 38, 79, 90; communal/collective trauma, 23, 46, 51; post-traumatic stress disorder, 1; and ritual, 78; as source

trauma (*cont.*)
 (instigator) of madness, 9–10, 46;
 trauma theory, 43

Ubuntu (spirit of humanity), 98n7
unconscious. *See* conscious/uncon-
 scious
 .

Volkan, V., 46

Wiener, Anthony, 67
Williams, Cootie, 78
Winnicott, D. W., 76, 88
Women in Peace Building, 98
Women's Peace and Security Network
 Africa, 98
Word Association Test, 44

Other Titles in the Carolyn and Ernest Fay
Series in Analytical Psychology:

The Stillness Shall Be the Dancing	Marion Woodman
Buddhism and the Art of Psychotherapy	Hayao Kawai
Gender and Desire	Polly Young-Eisendrath
The Archetypal Imagination	James Hollis
Soul and Culture	Roberto Gambini
Joy, Inspiration, and Hope	Verena Kast
Transformation	Murray Stein
Integrity in Depth	John Beebe
The Two Million-Year-Old Self	Anthony Stevens
Memories of Our Lost Hands	Sonoko Toyoda
The Old Woman's Daughter	Claire Douglas
Ethics and Analysis: Philosophical Perspectives and Their Application in Therapy	Luigi Zoja
The Black Sun: The Alchemy and Art of Darkness	Stanton Marlan
Synchronicity: Nature and Psyche in an Interconnected Universe	Joseph Cambray
The Therapeutic Relationship: Transference, Countertransference, and the Making of Meaning	Jan Wiener
Connecting with South Africa: Cultural Communication and Understanding	Astrid Berg
Finding Jung: Frank N. McMillan Jr., a Life in Quest of the Lion	Frank N. McMillan III